*To those who have toiled to restore
the wall-paintings*

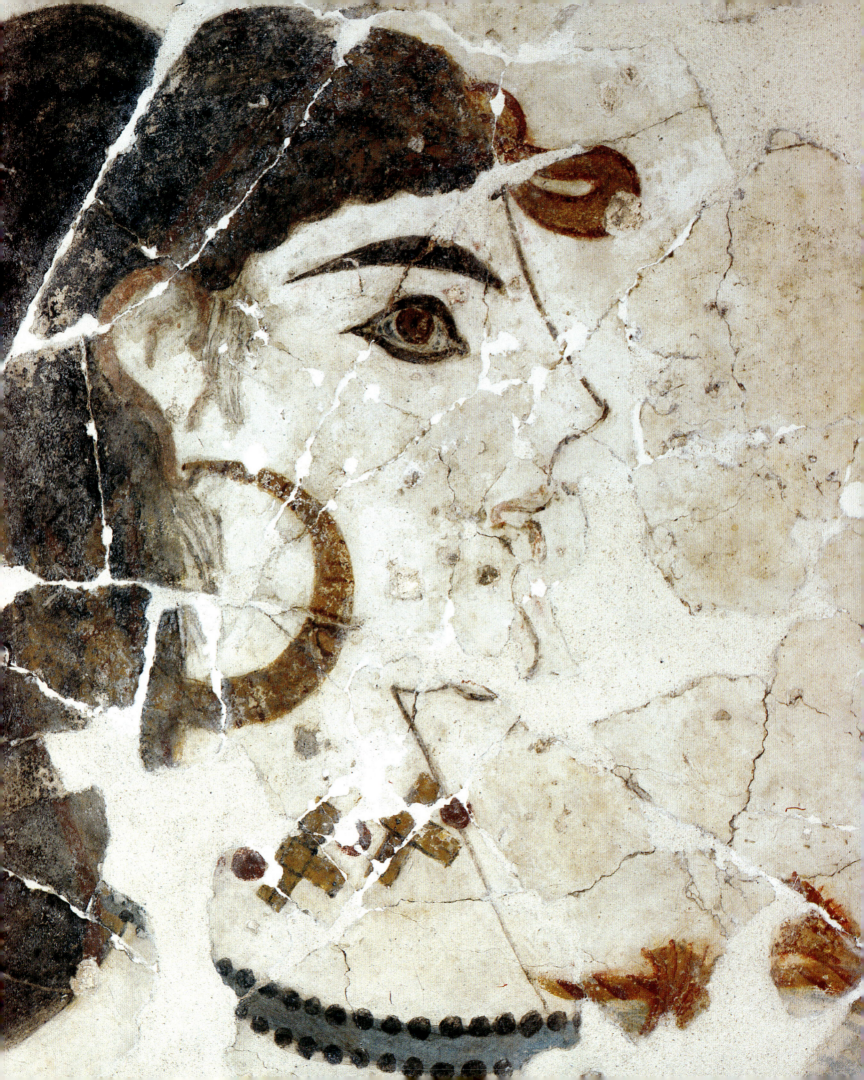

THE WALL-PAINTINGS OF THERA

PUBLISHED BY: KAPON EDITIONS

DESIGN: RACHEL MISDRAHI-KAPON

EDITORIAL COORDINATOR: DAVID A. HARDY

DESIGN AND PRODUCTION: RACHEL MISDRAHI-KAPON

TEXT EDITED BY: DIANA ZAFIROPOULOU

ARTISTIC ADVISOR: MOSES KAPON

PHOTOGRAPHS:

JÜRGEN LIEPE
fig. nos. 2-5, 14-17, 49-64, 66-76, 82, 87-90, 93-108, 116-121, 127,
130-146, 148-151, and photographs of the archaeological site

SERGE BRIEZ/ART'HIST
fig. nos. 6-12, 18-25, 78-81, 83-86, 91, 109-115, 122-126, 128, 129, 147

H. IOSSIFIDES – G. MOUTEVELLIS
fig. nos. 26-48

PUBLICATION ASSISTANT: NIKI KONIDE

TYPE-SETTING: G. ATHANASIOU

COLOUR SEPARATION: SELECTOR LTD

REPRODUCTION OF PLANS: MIHAILIDES BROS

STRIPPING: M. PENTARIS – G. KOULEPAKIS

PRINTING: A. PETROULAKIS

BINDING: G. MOUTSIS – G. ILIOPOULOS

©THE THERA FOUNDATION – PETROS M. NOMIKOS
17-19 Akti Miaouli, 185 35 Piraeus, Tel.: 4170895, 4179295

ISBN 960-220-274-2

Printed and bound in Greece, 1992

THE WALL-PAINTINGS OF THERA

Text: CHRISTOS DOUMAS
Translation: ALEX DOUMAS

THE THERA FOUNDATION
PETROS M. NOMIKOS

ATHENS 1992

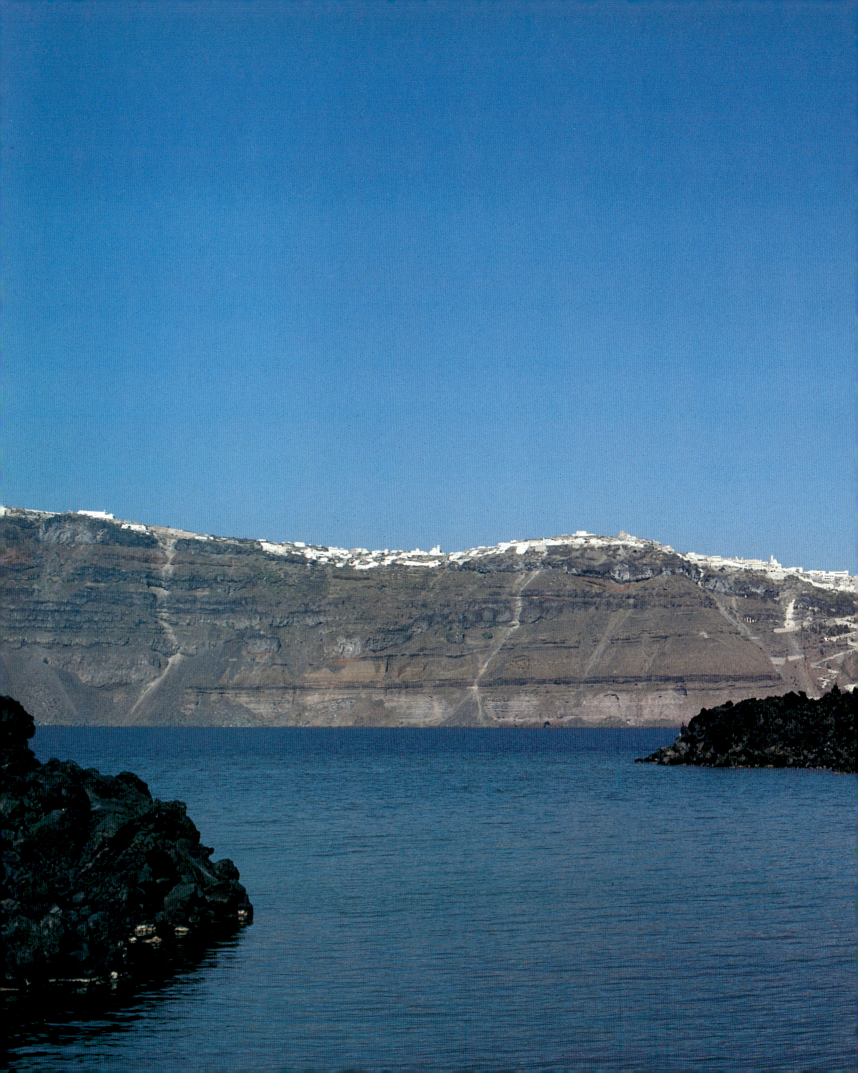

Contents

The excavation of Akrotiri, Thera, under the directorship originally of the late Professor Spyridon Marinatos, and since his untimely death in 1974 that of Professor Christos Doumas, has been from its outset in 1967 under the sponsorship of the Archaeological Society of Athens. This Bronze Age city, which flourished thirty-six centuries ago, has produced a wealth of material, foremost amongst which are the artistically superb wall-paintings. The Thera Foundation is grateful to the Archaeological Society of Athens for agreeing to the publication of the present volume, containing all the wall-paintings restored to date. Warm thanks are also extended to Professor Doumas whose introduction and detailed descriptions give a clear, well-documented picture of these early masterpieces, and the technique of wall-painting.

Most of the wall-paintings were discovered by 1974. About half of them have been on exhibition in the National Archaeological Museum in Athens since the early 1970s and have been published in many archaeological studies and reports as well as reproduced in several popular books and in tourist material, not always with the quality they deserve. The other half have remained not only unpublished but also out of sight, stored in Athens, at the site of Akrotiri itself and in a museum on Santorini which, considered unsuitable for visitors, has not yet been opened to the public.

The purpose of this publication has been to present these unique works of art in a comprehensive way and with the highest standards of fidelity – a task that has long been overdue. All credit is due to Mrs Rachel Misdrahi-Kapon, who conceived the ideas for the design, and was responsible for the production of this book.

The Thera Foundation hopes that by making all the wall-paintings of Akrotiri widely available for study and enjoyment it is making a significant contribution to the understanding of early Aegean culture.

PETER M. NOMIKOS
President, The Thera Foundation

Foreword

The discovery of the wall-paintings at Akrotiri, Thera, in the excavations (1967-1974) of Professor Spyridon Marinatos is of outstanding importance for our knowledge of the early Aegean world. It ranks alongside Schliemann's opening of the Shaft Graves of Mycenae in 1876 and Evans's uncovering of the palace of Knossos with its collections of inscribed tablets in 1900. The conservation, study, discussion and presentation of the paintings since 1974, under the leadership of Professor Christos Doumas, is brought to fruition by him in this volume.

The extent of their preservation, and thus of their informational value, is one reason for the paintings' importance. By a remarkable quirk of nature the same event, a great eruption of the Thera volcano, was the agent of destruction and preservation. As with the treasures of Pompeii and Herculaneum, the paintings of Thera would never have survived without their seal of pumice from the volcano. The contrast with the great works of Minoan Crete to the south could hardly be sharper. Our knowledge of those paintings has to be reconstructed from thousands of exiguous scraps. At Thera the decorative schemes are often substantially complete. Only the parietal art of the French and Iberian Palaeolithic caves, the tombs of Middle and New Kingdom Egypt and of the Etruscans offer comparable preservation from the millennia before Roman times.

Secondly, the Theran works are of exceptional value as art. They offer a marvellous quality of information for both aesthetic and technical investigation – that is for investigation of style, composition, chromatic relationships and values, and the conceptualization of space, and for techniques of manufacture and choice of painting and plaster materials.

Of greater importance still is the subject matter, the contents of the paintings. It is an astonishing fact that the many paintings so far uncovered or tantalizingly awaiting new excavation or conservation are all different from each other. Some, like the Monkeys from Complex B and per-

haps the Crocus-gatherers and Goddess from Xeste 3, are more or less paralleled, though in a very fragmentary way, in Crete; others, like the city apparently under attack in the West House Miniature Frieze, recall similar scenes in relief stonework and metalwork, and in faience; these interconnections suggest a genre in different visual materials which reflected contemporary practice, such as sea-raiding or other activities; yet other paintings – for example the monkeys using human artefacts – are *sui generis*. All contribute major evidence to current debates of first principles in approaching the symbolism and iconography in cultures different from our own; in other ways, such as the use of plants, the paintings offer evidence not of difference but of remarkable continuity of practice in the Cycladic islands through to the present day. Meanwhile it is a sign of healthy scholarship that interpretation, as distinct from the methodology of interpretation, varies according to the perspectives of the researcher; thus both secular/social and religious emphases have been seen behind apparent *rites de passage* of youths and girls who are the subjects of different paintings in several buildings.

In matters of detail too the paintings have provided totally unexpected information. Assuming that specific depictions reflect real life forms in the Aegean world, we find amazing evidence for ships, their size and construction, for urban architecture, for the richness of dress and jewellery, and for the natural environment of plants and animals. The paintings of Minoan Crete, notably at Aghia Triadha, Amnisos and Knossos, had given us knowledge of flora and fauna, which Thera has now greatly enriched and amplified.

Yet another contribution made by the works of Akrotiri is their contextual association. This is a matter well developed by Christos Doumas in his earlier book, *Thera: Pompeii of the Ancient Aegean* (1983). The abundant preservation of artefacts, often more or less *in situ*, in rooms decorated by paintings with known wall positions provides contextual information at a level not reached even in the Roman Neapolitan towns and villas. Thus at Akrotiri much more plausible assessments can now be made not only of the functions of individual rooms or areas, but also of buildings as a whole, through study of the internal connexions between rooms or units with such rich contextual evidence.

Finally, the Thera paintings present a brilliant new chapter in the history of Aegean painting. The development can be followed from the first red-painted walls of Cretan Early Bronze Age villages through the abstract geometrical wall and floor patterns of the protopalatial period at Phaistos and on to the apogee of the Late Bronze Age. The site of Tell el-Dabá in Egypt (ancient Avaris of the Hyksos people) is now giving us what appear to be wholly Minoan paintings of bull-leapers at a date contemporary with or a little earlier than the paintings of Akrotiri. Highly significant as these paintings in Egypt are for the history of Aegean painting and its subject matter, it is the peerless treasures of Thera which permit a wholly new and noble level of understanding of that history.

PETER WARREN

Professor of Ancient History and Classical Archaeology

Bristol University, England

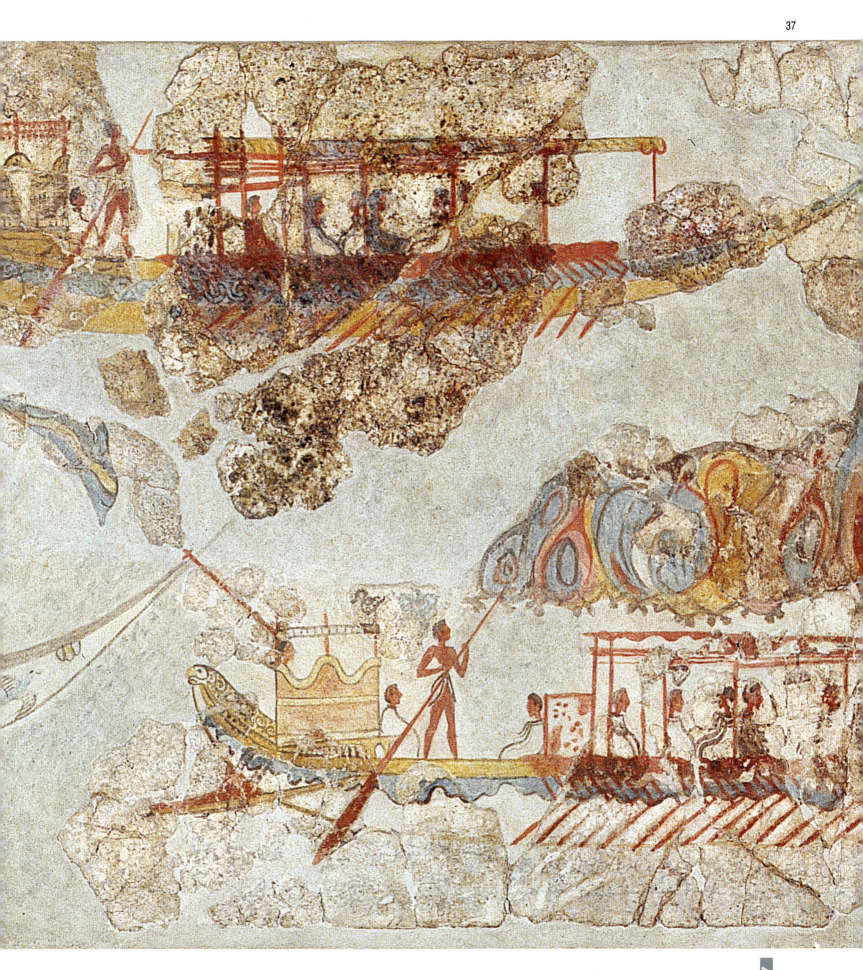

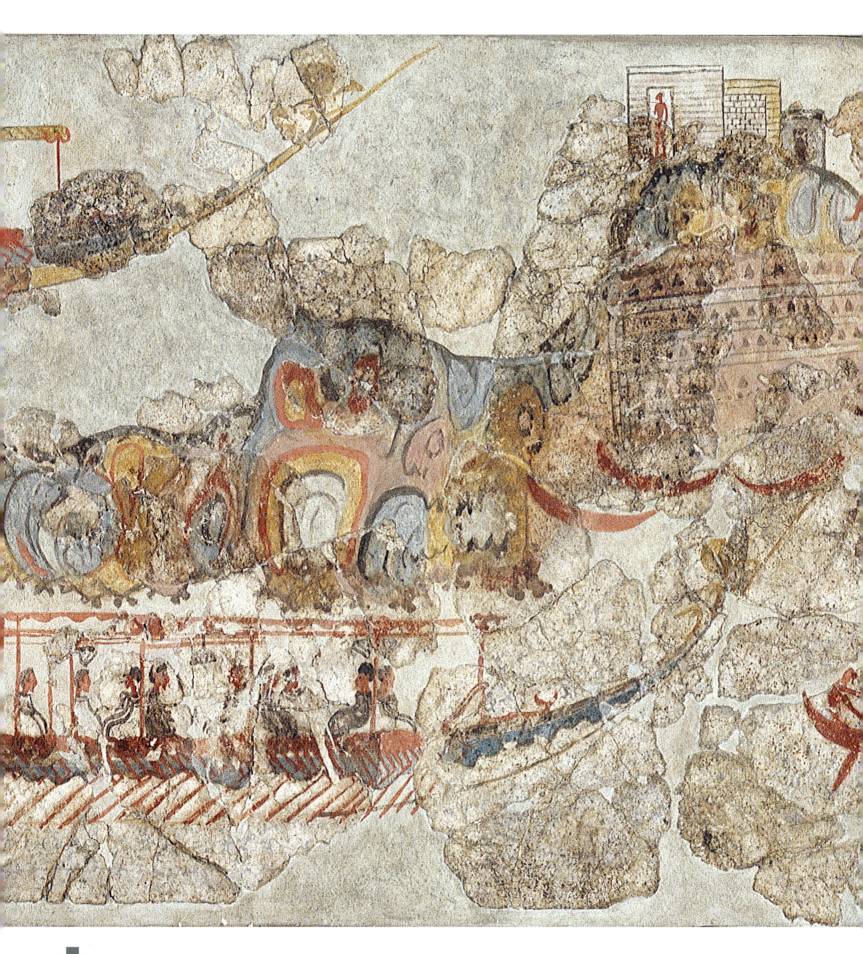

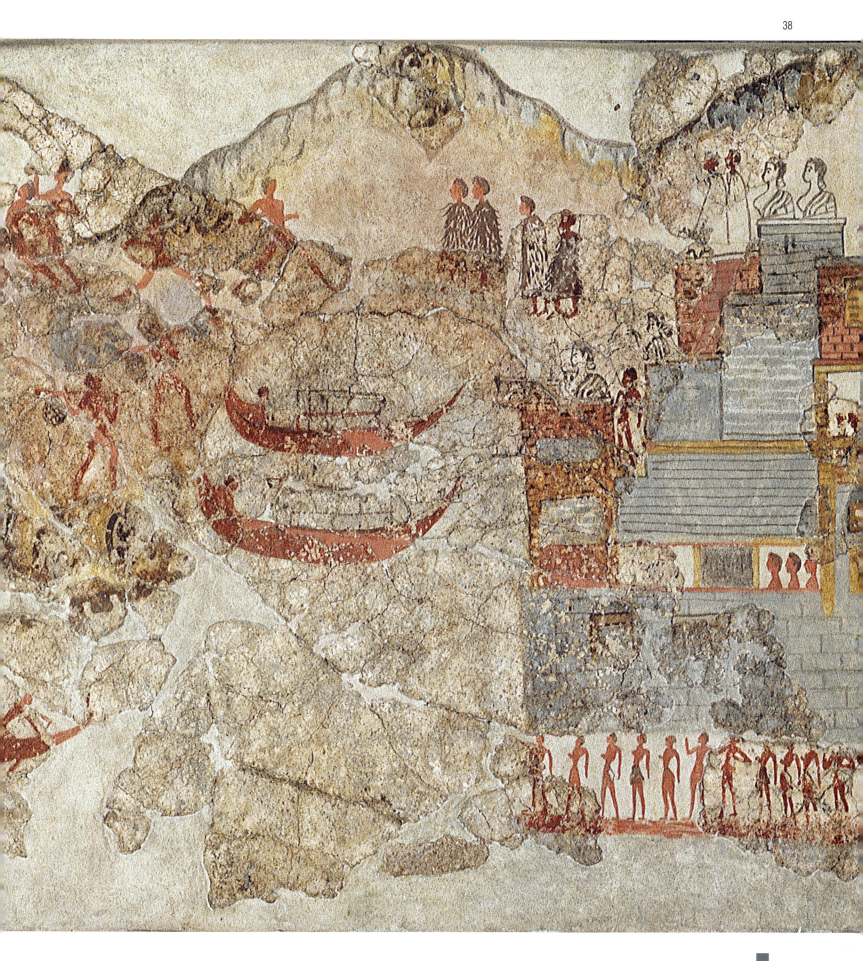

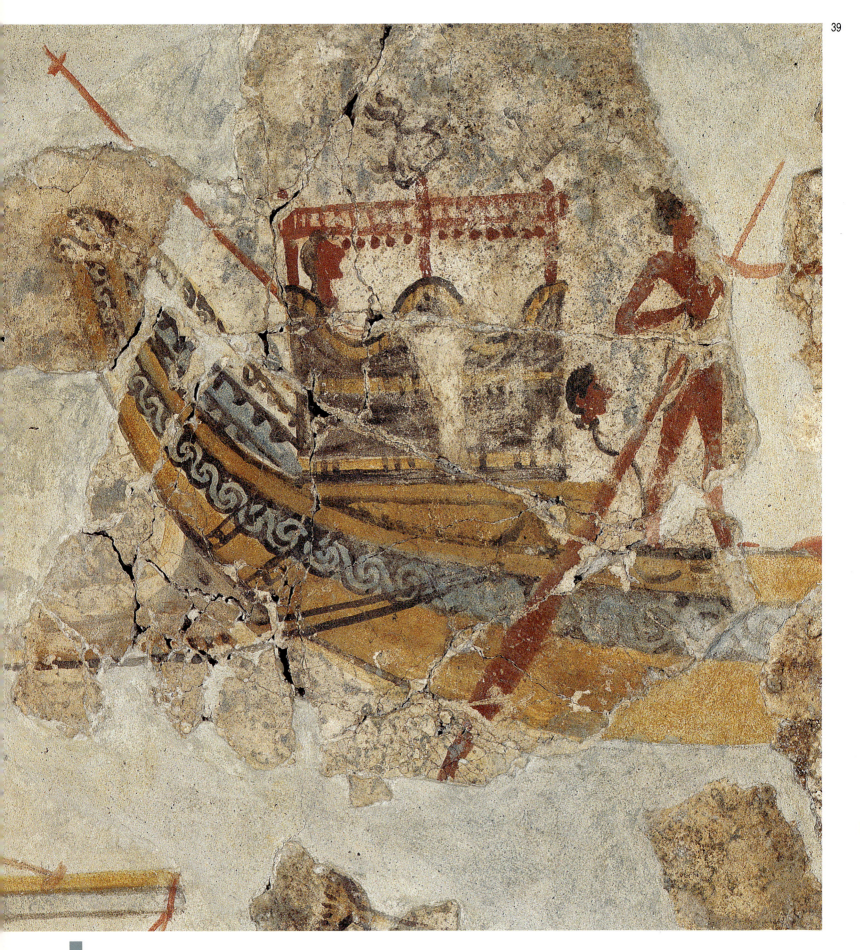

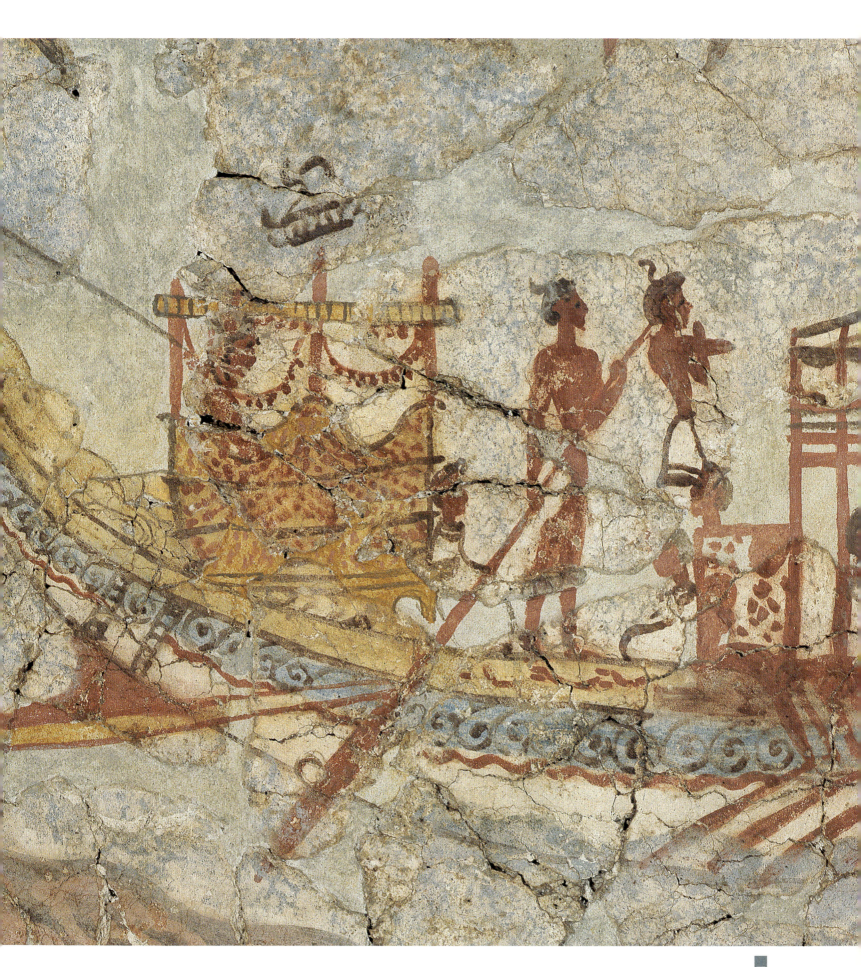

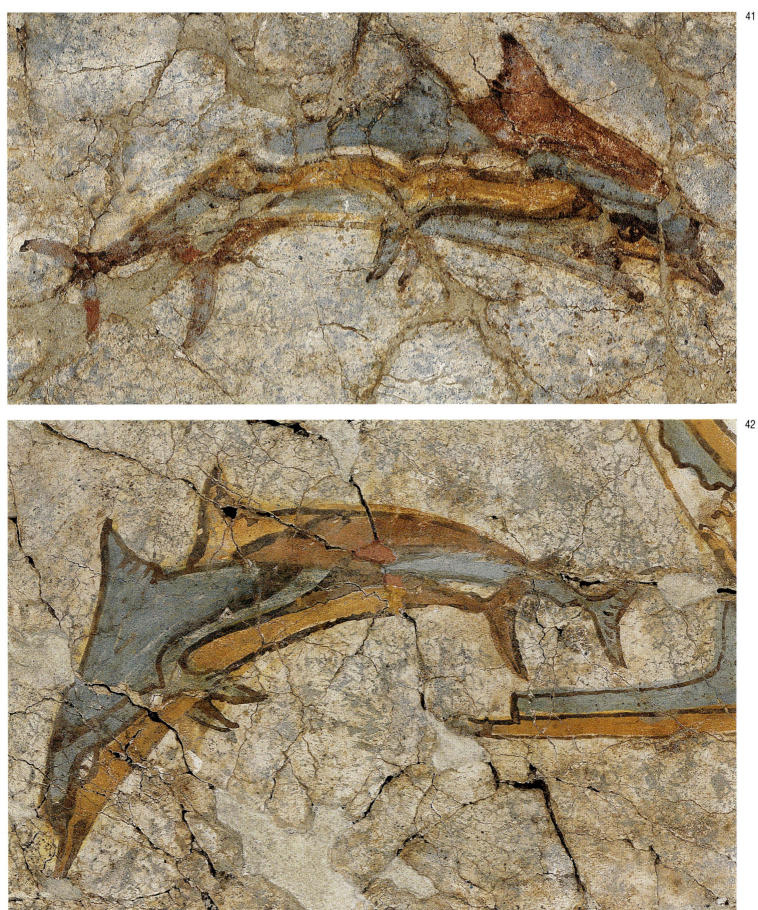

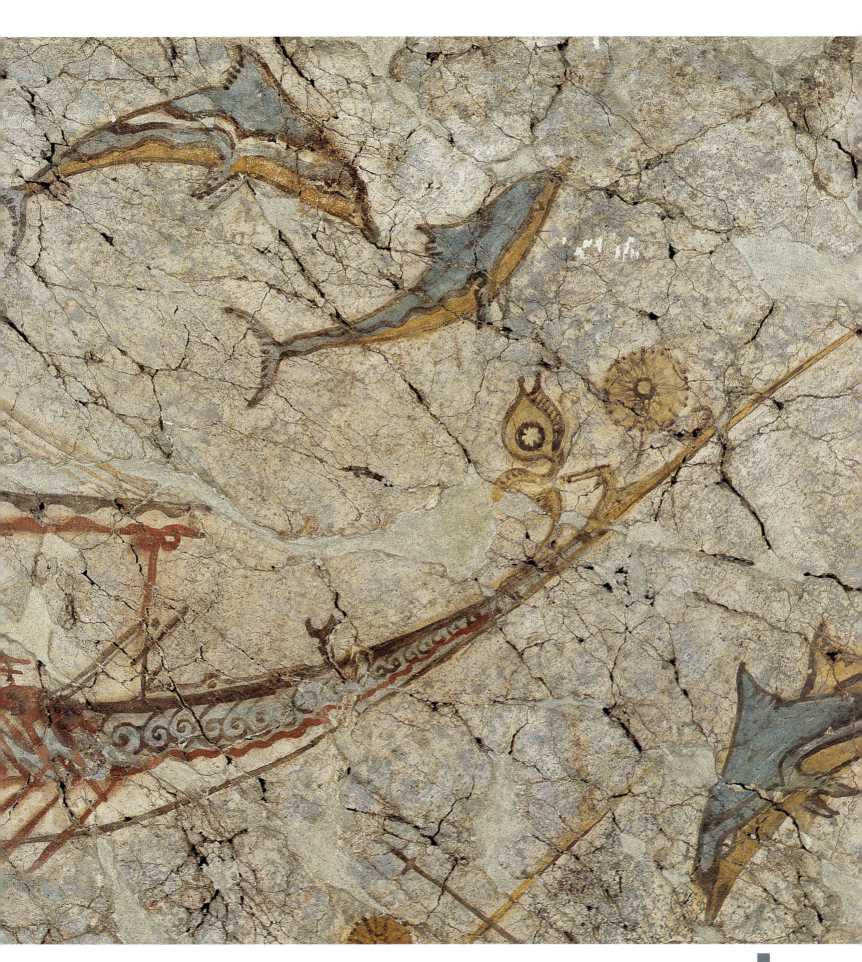

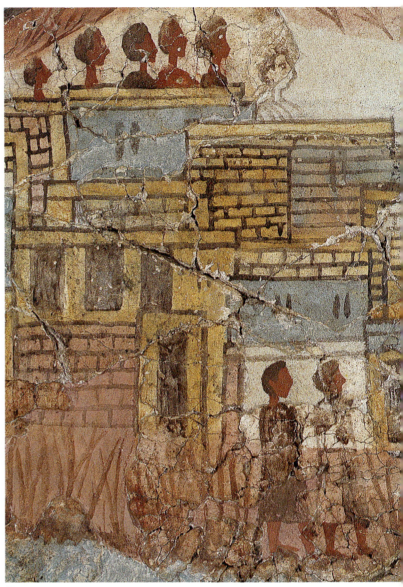

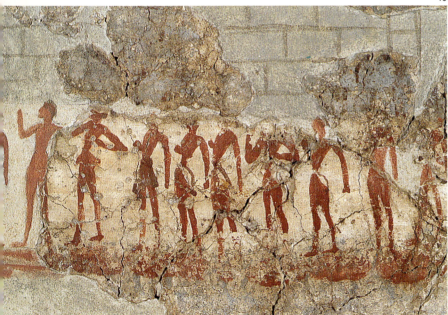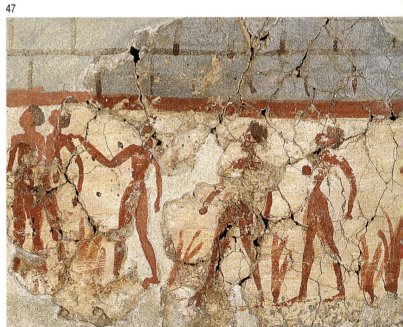

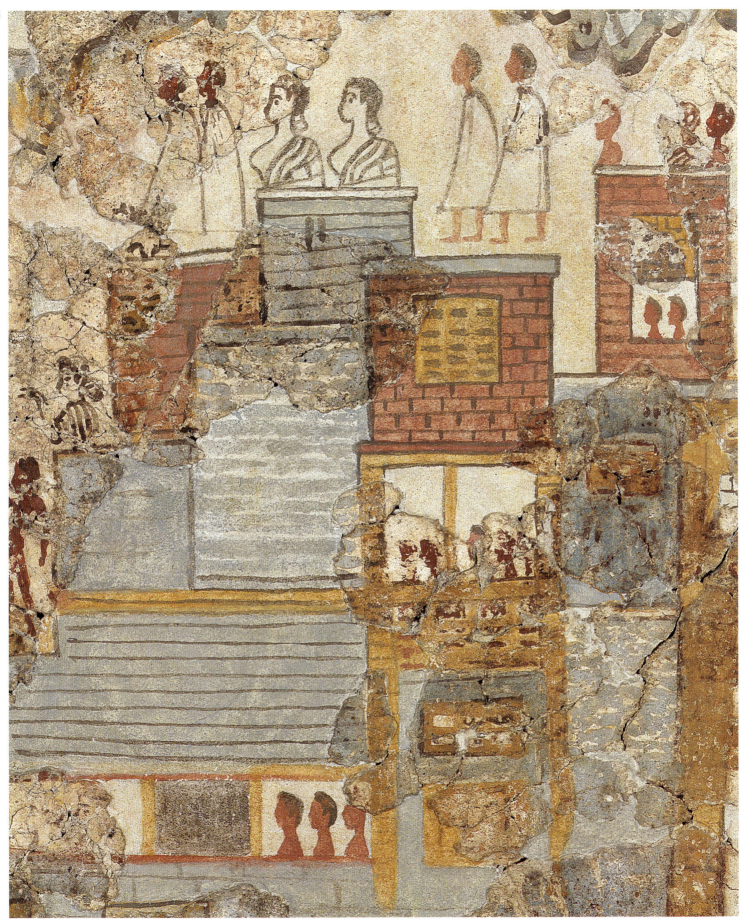

49. Room 4. East wall:
Half *Ikrion*.
H. 1.80, W. 0.50 m.

49

50. Room 4.
South wall: Two *Ikria*.
H. 1.80, W. 2.12 m.

50

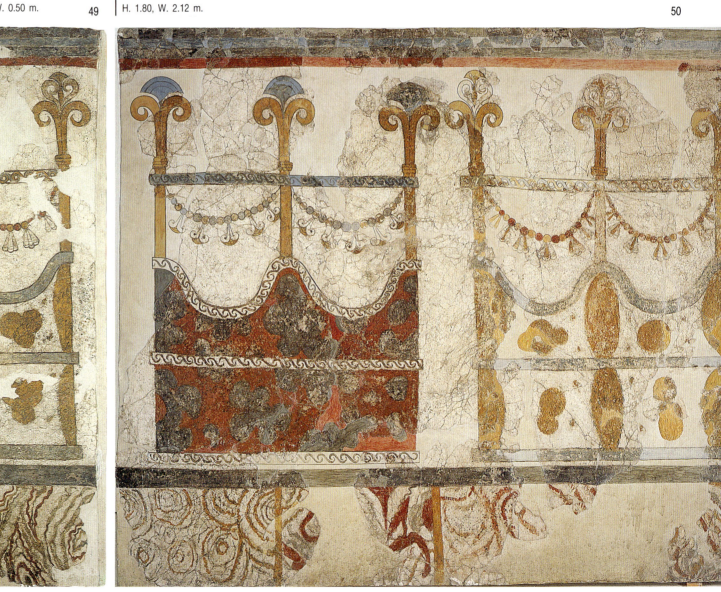

51. Room 4. West wall: *Ikrion.*
H. 1.95, W. 1.98 m.

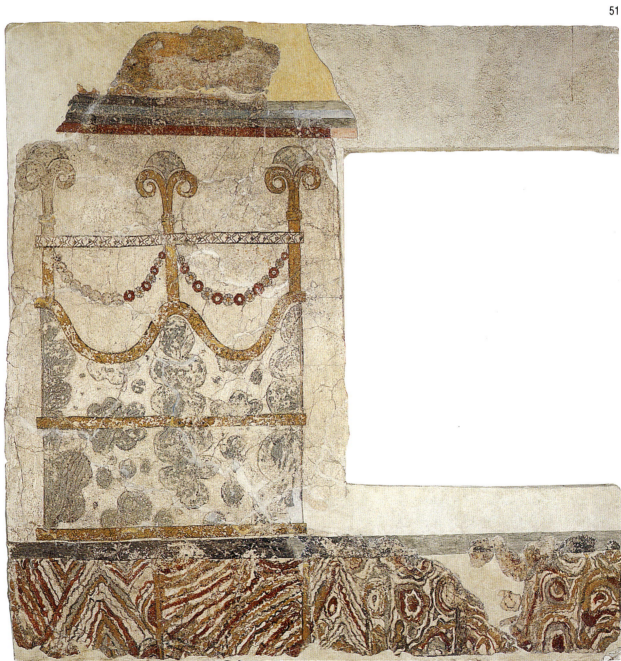

55

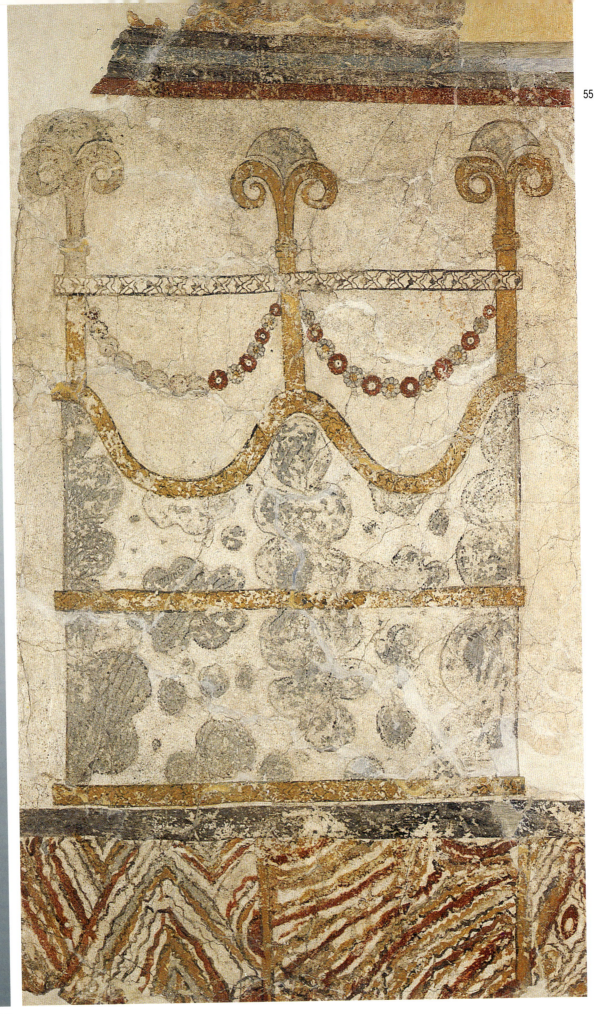

55-62. Details.

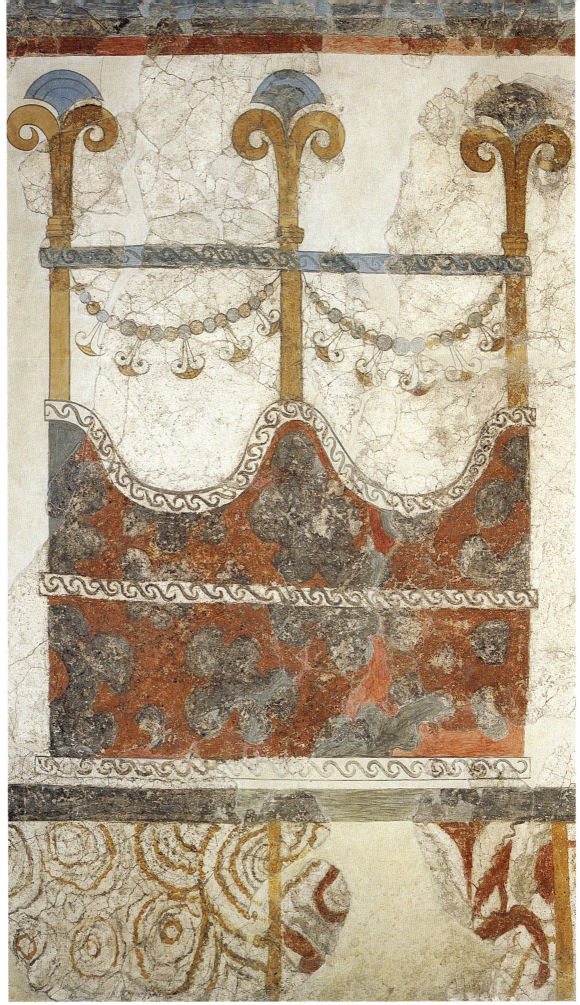

56

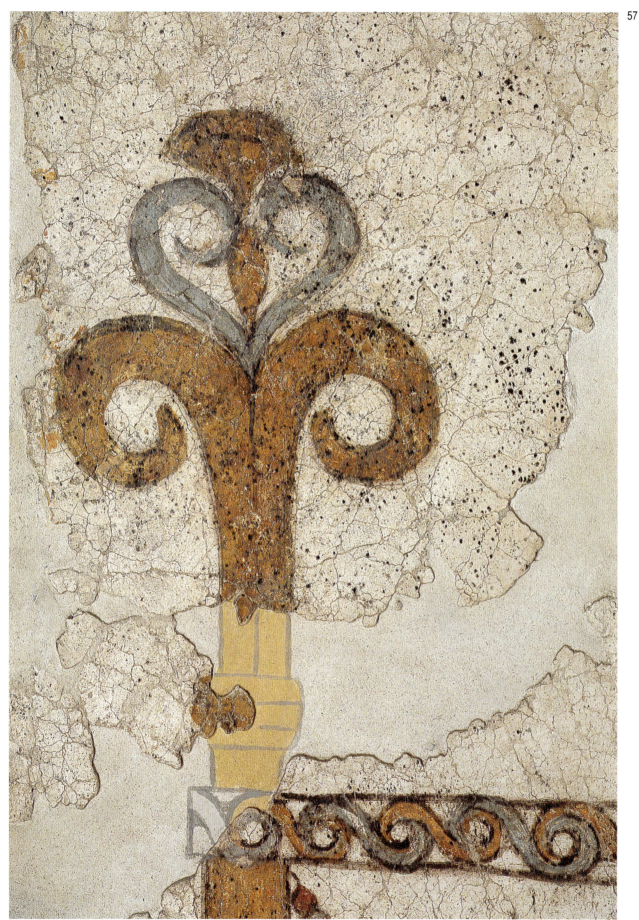

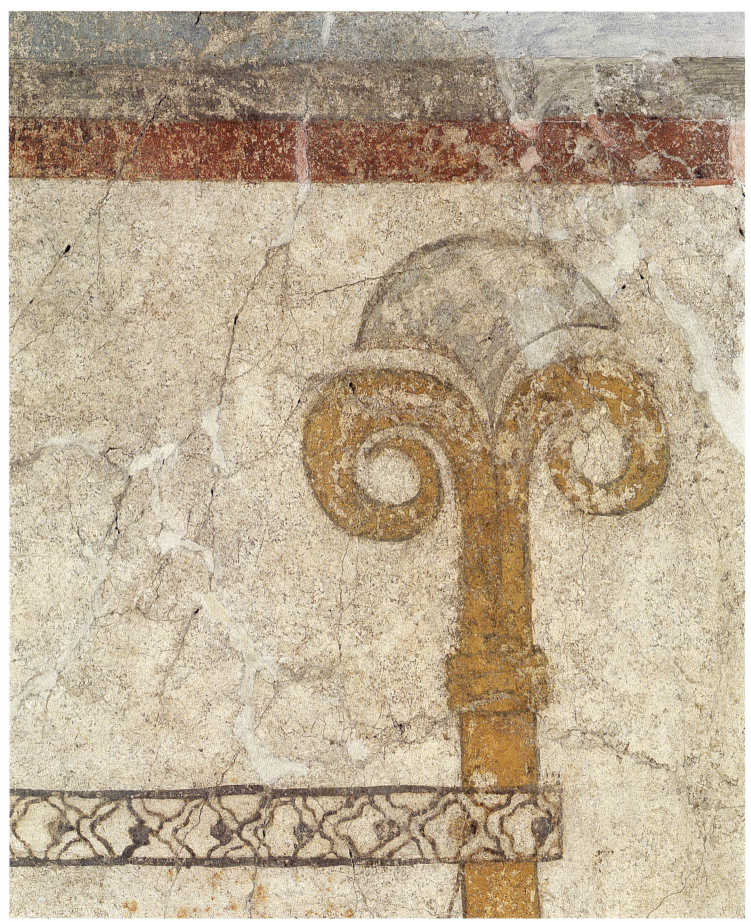

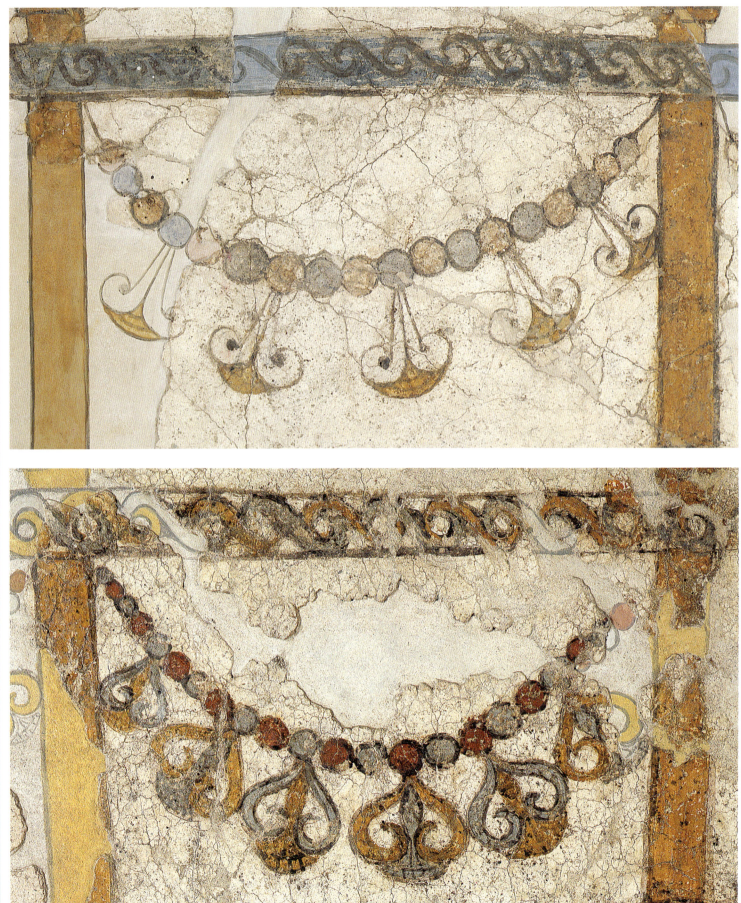

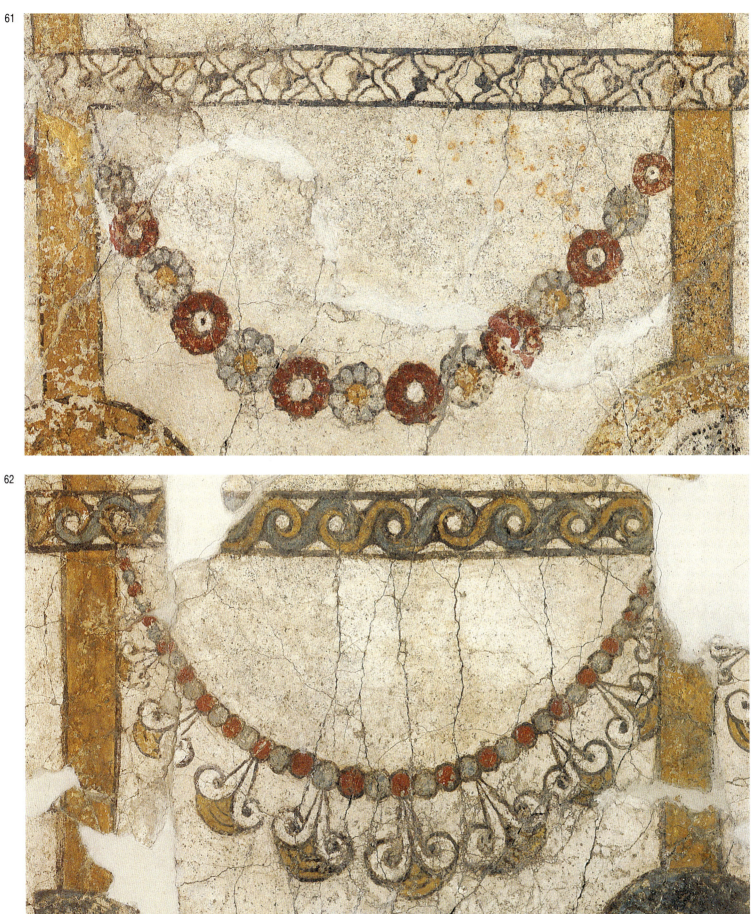

61

62

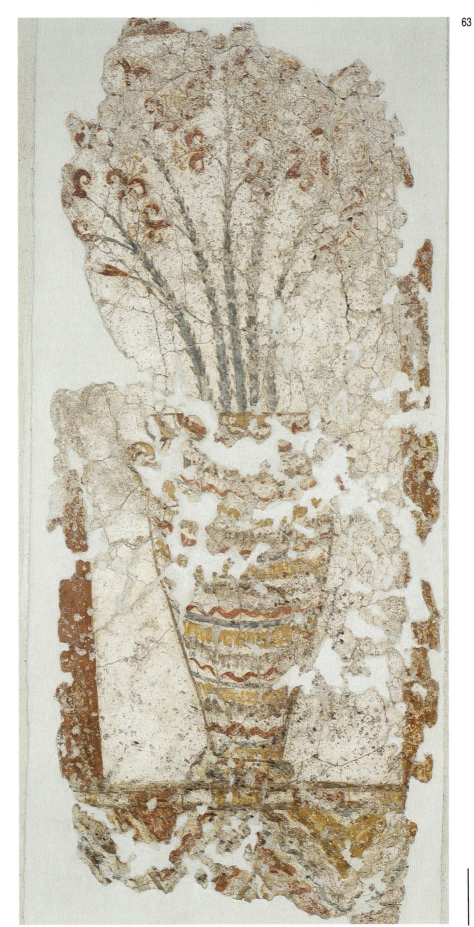

63. Room 4.
Window. North jamb:
Flower Vase.
H. 0.89, W. 0.45 m.

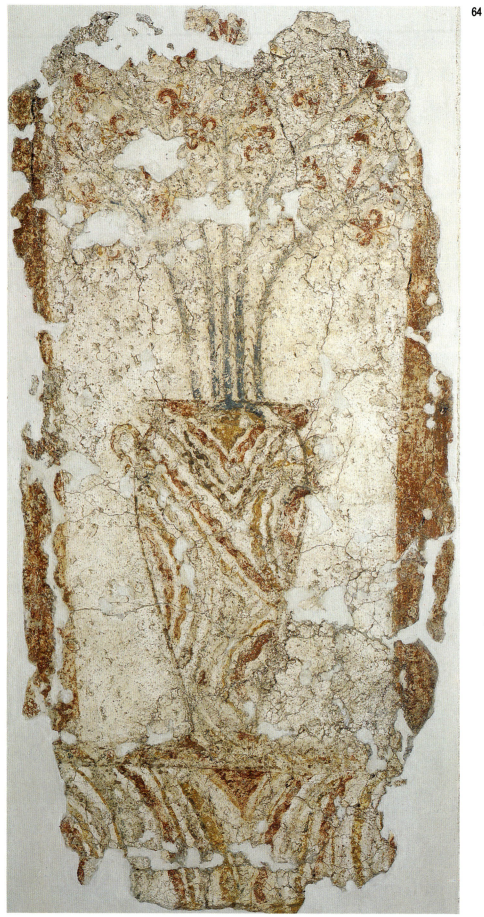

64. Room 4.
Window. South
jamb: Flower Vase.
H. 0.85, W. 0.39 m.

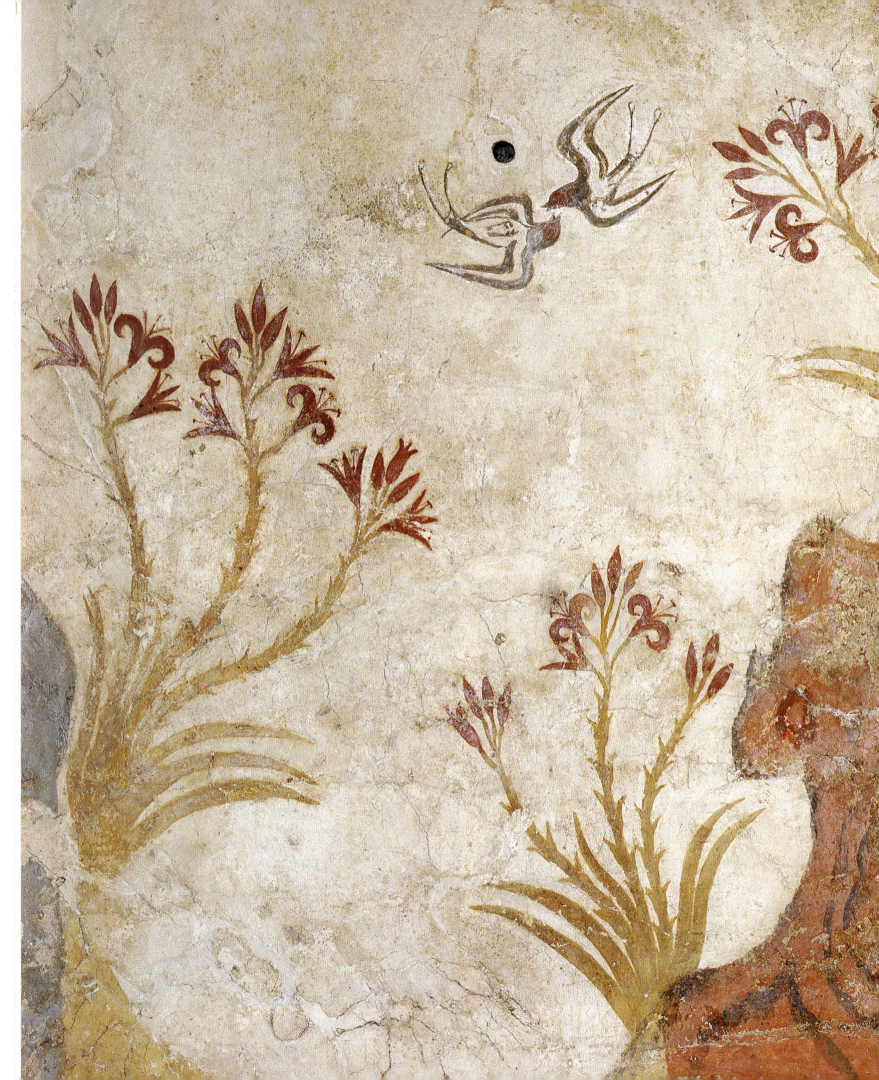

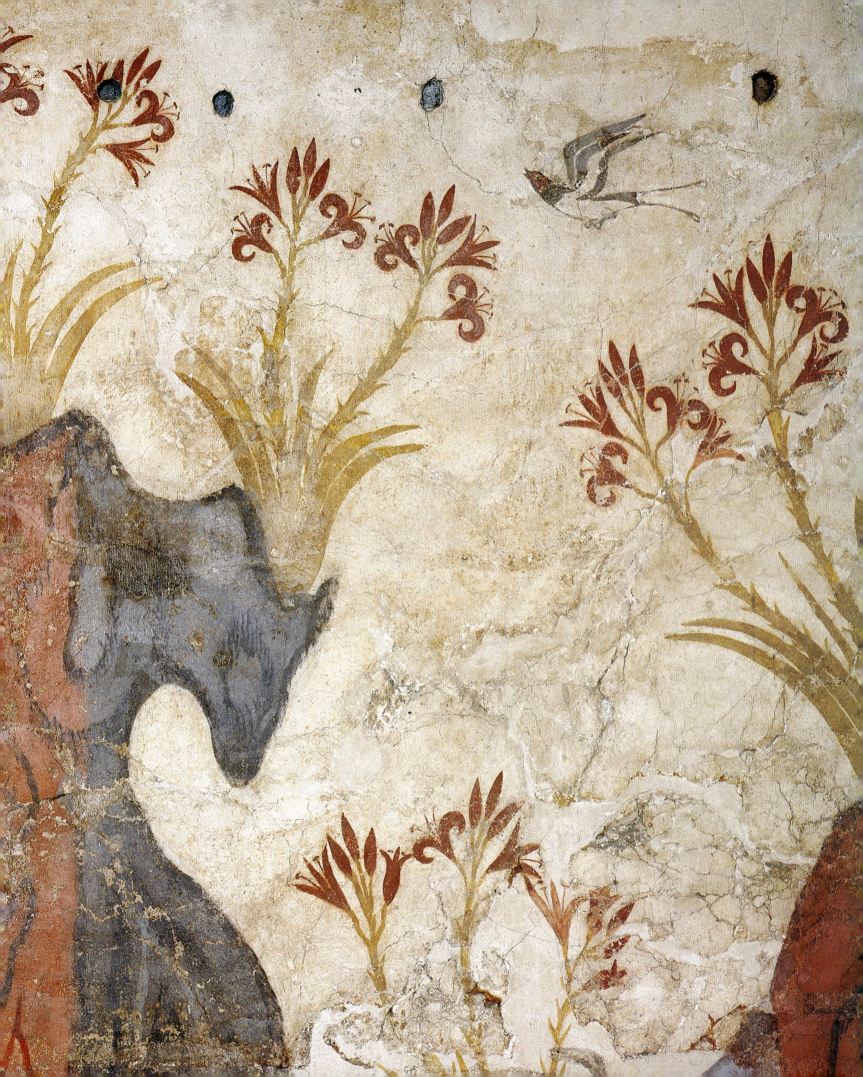

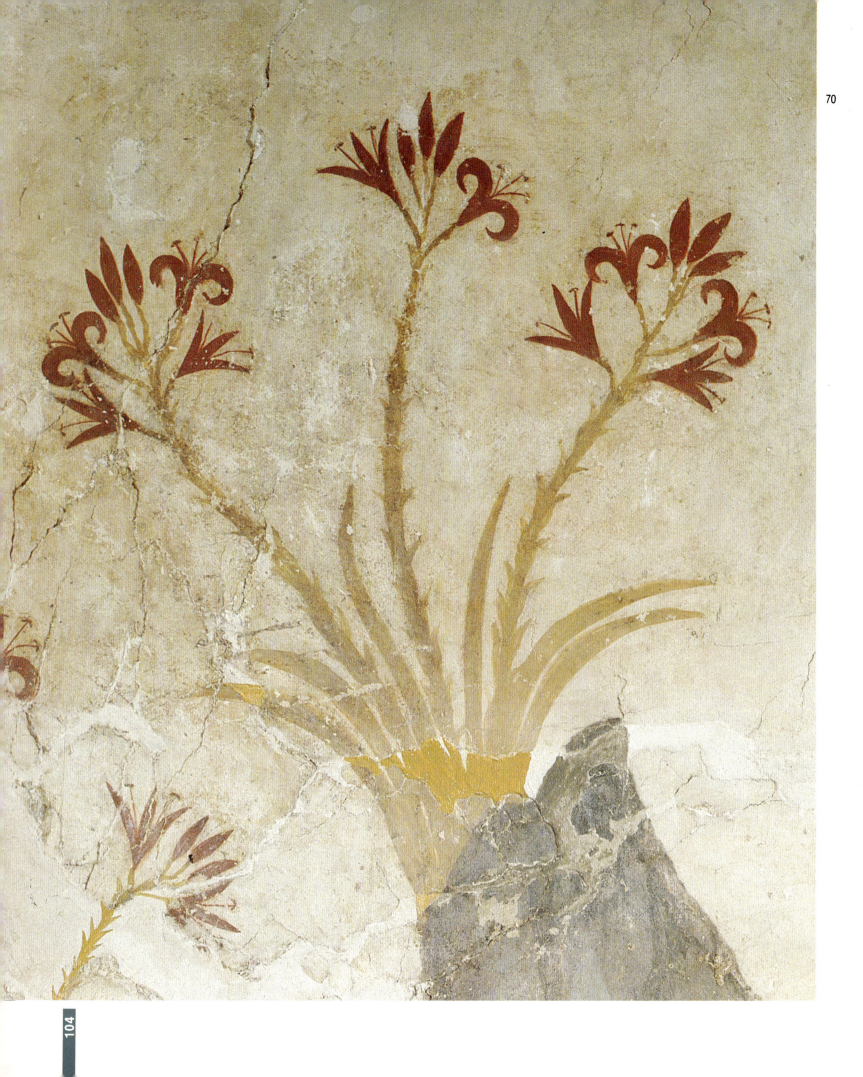

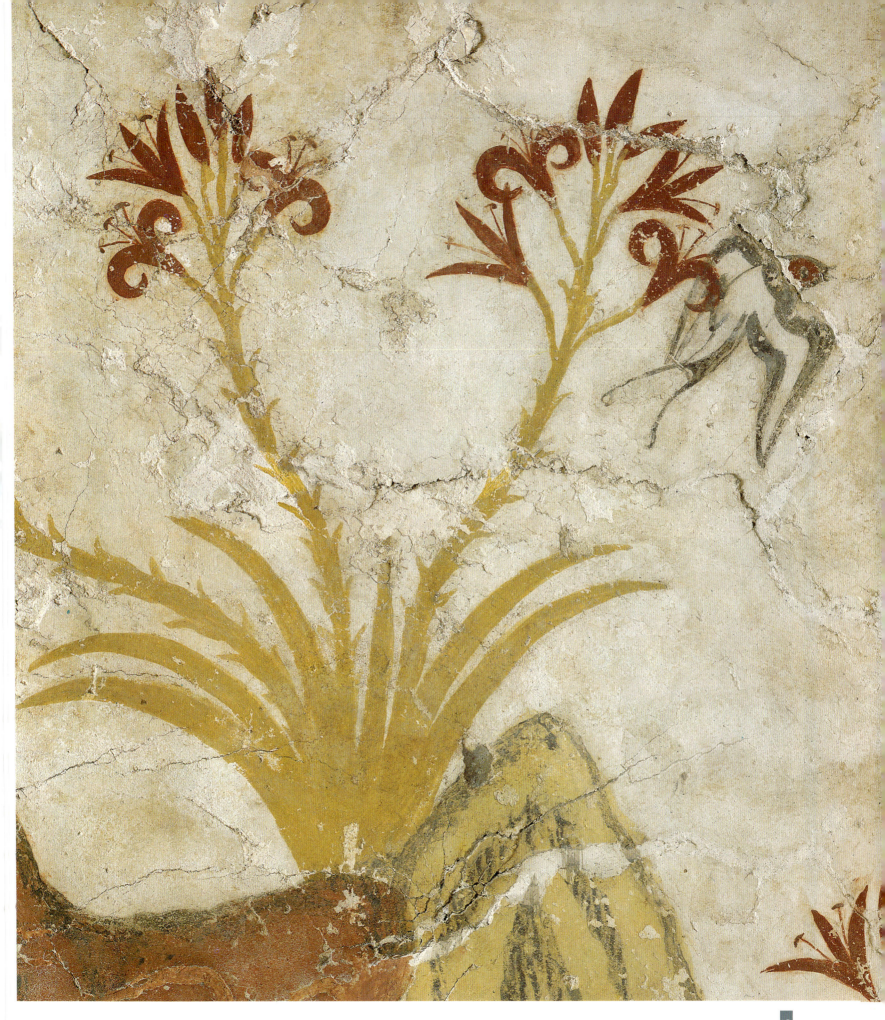

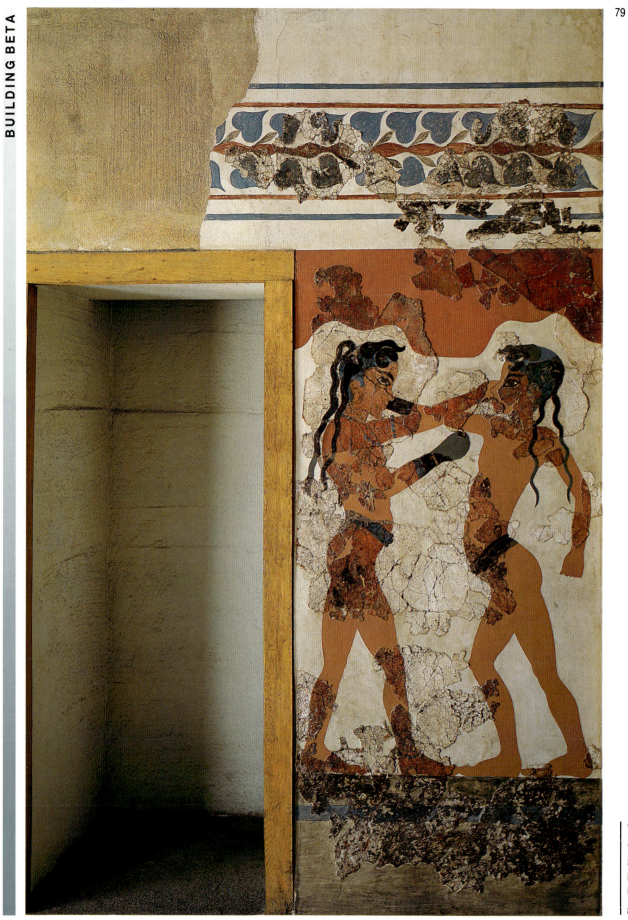

78. Detail.

79. Room Beta 1.
South wall:
Boxing Boys.
H. 2.75, W. 0.94 m.

80-81. Details.

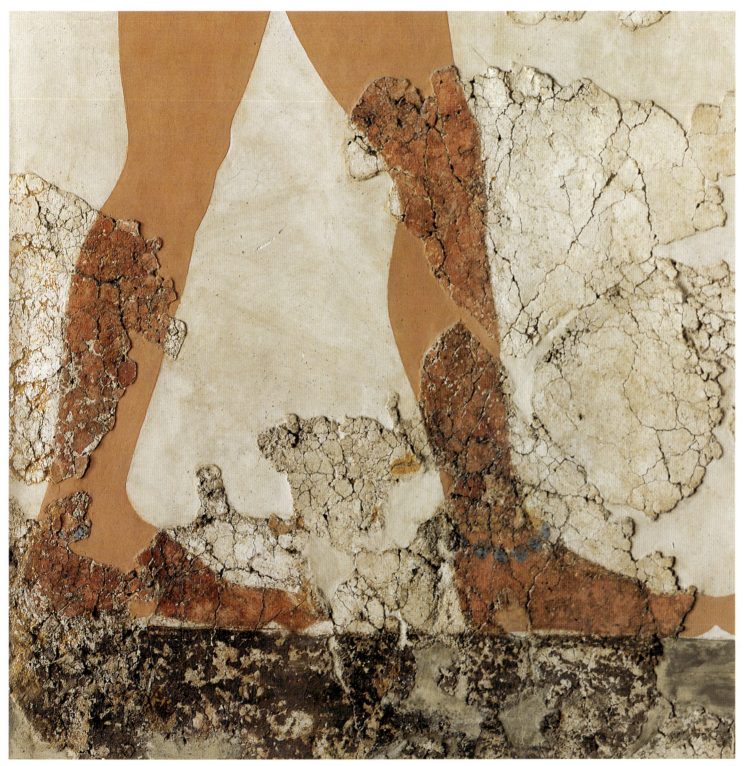

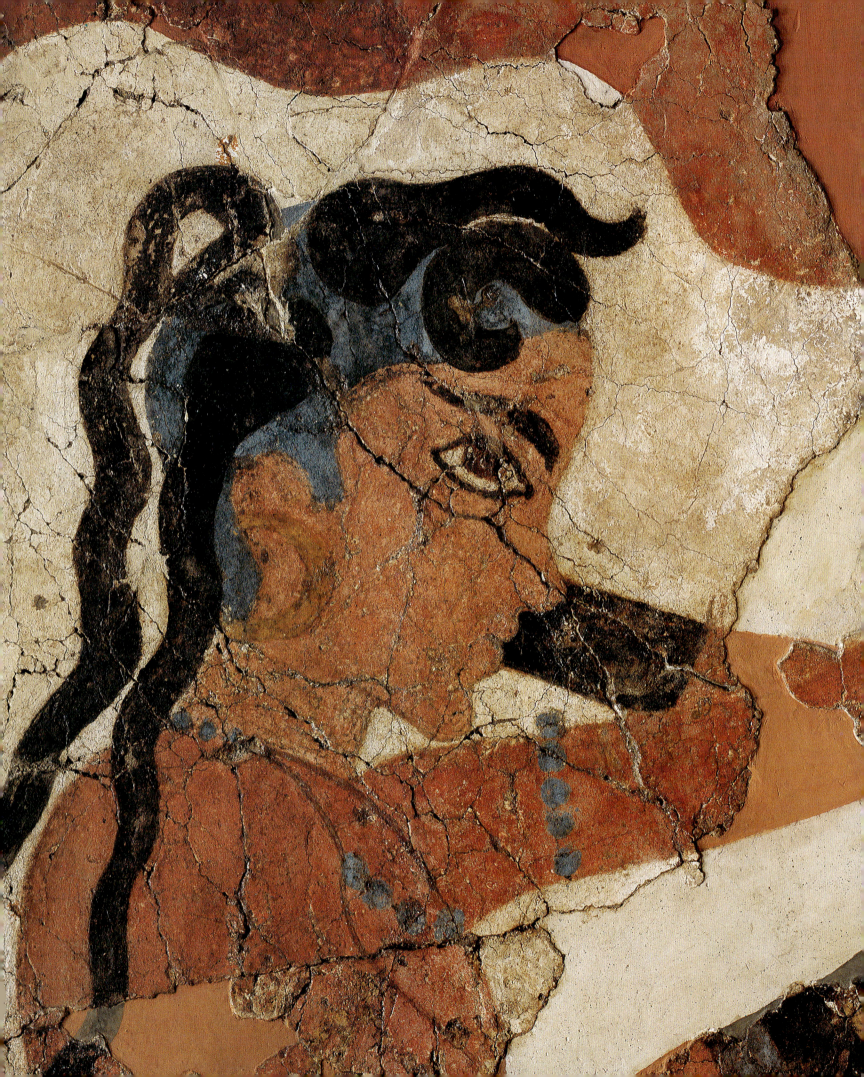

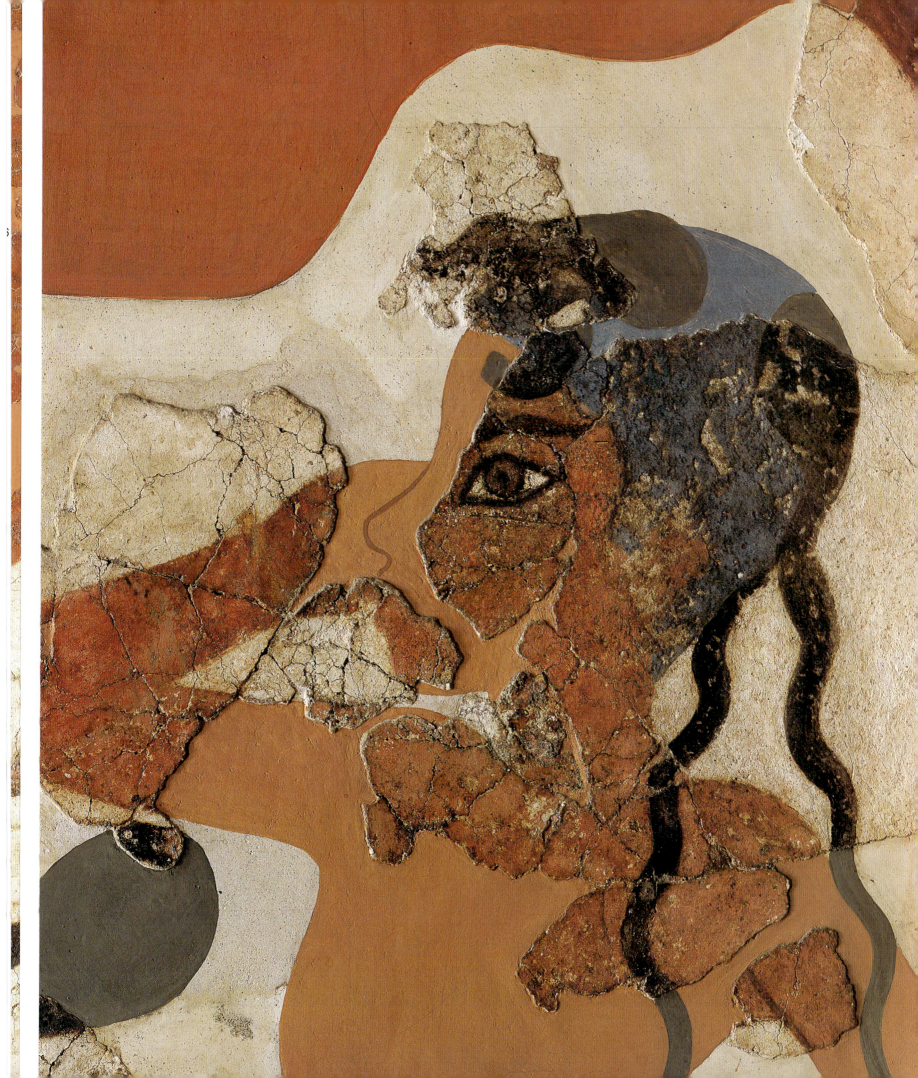

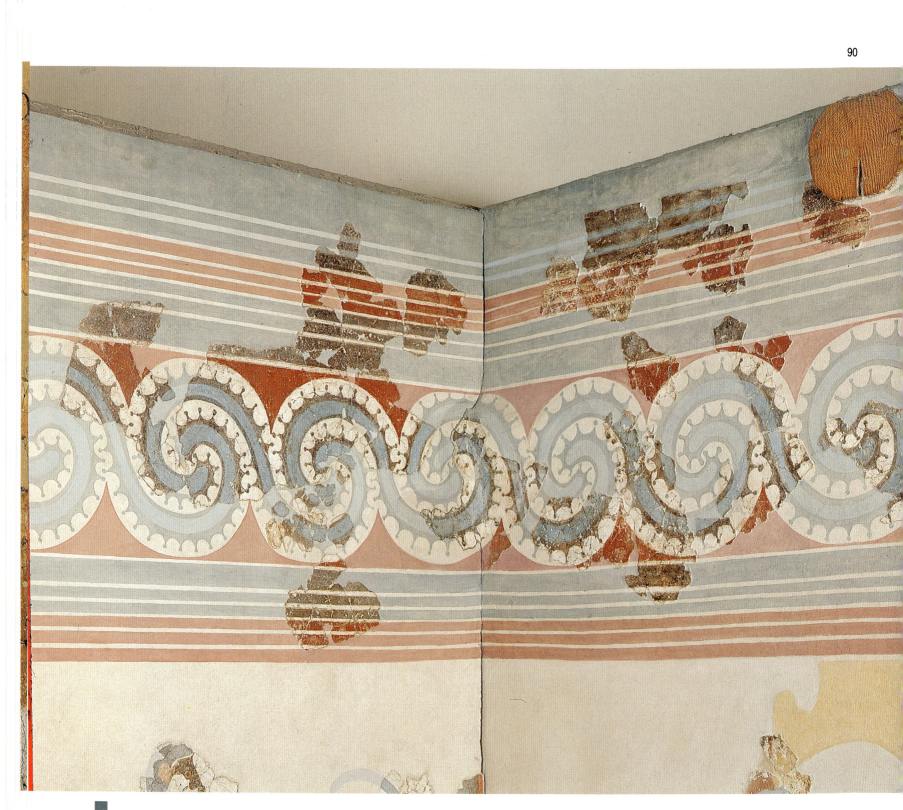

91. Room Beta 6.
'Cows'.
H. 1, W. 1.10 m.

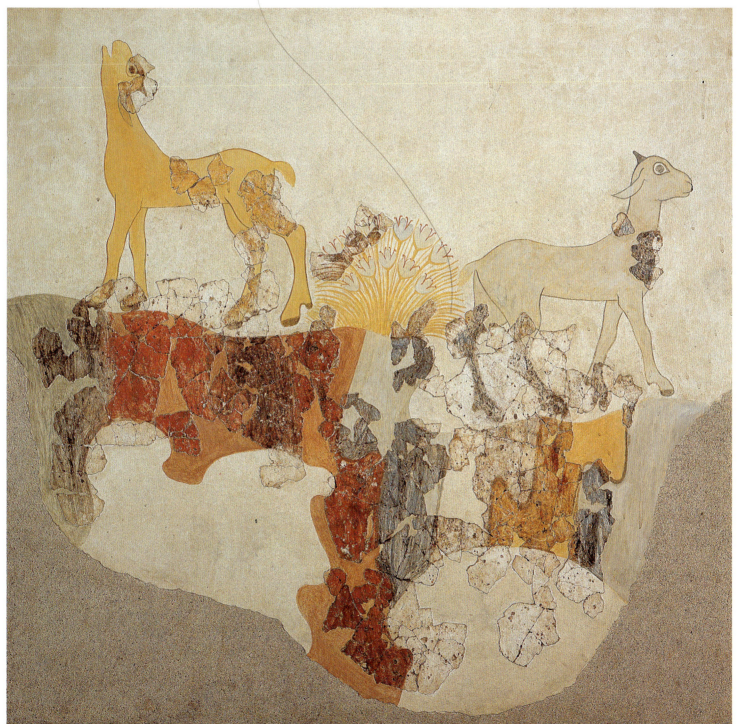

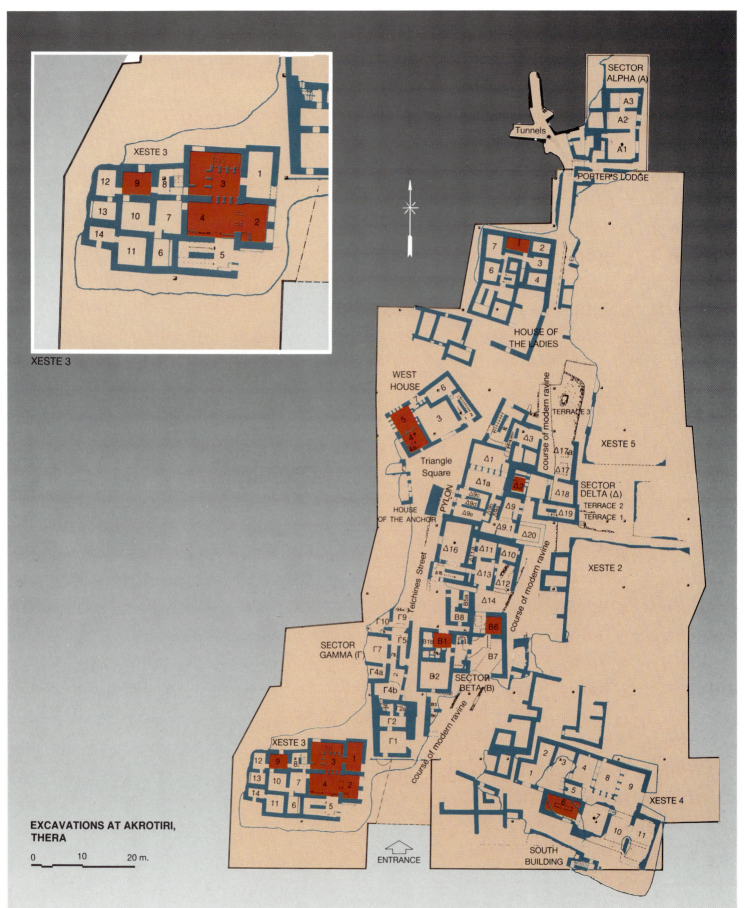

XESTE 3

EXCAVATIONS AT AKROTIRI, THERA

0 10 20 m.

92

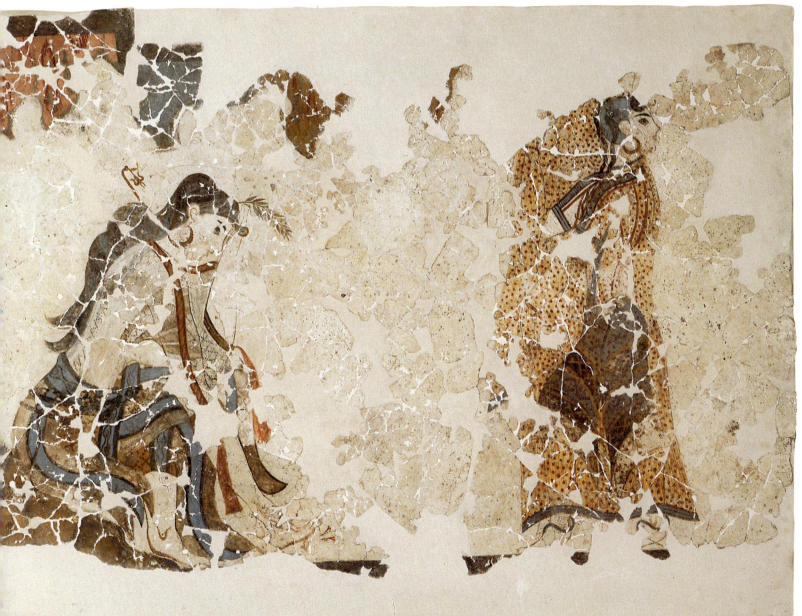

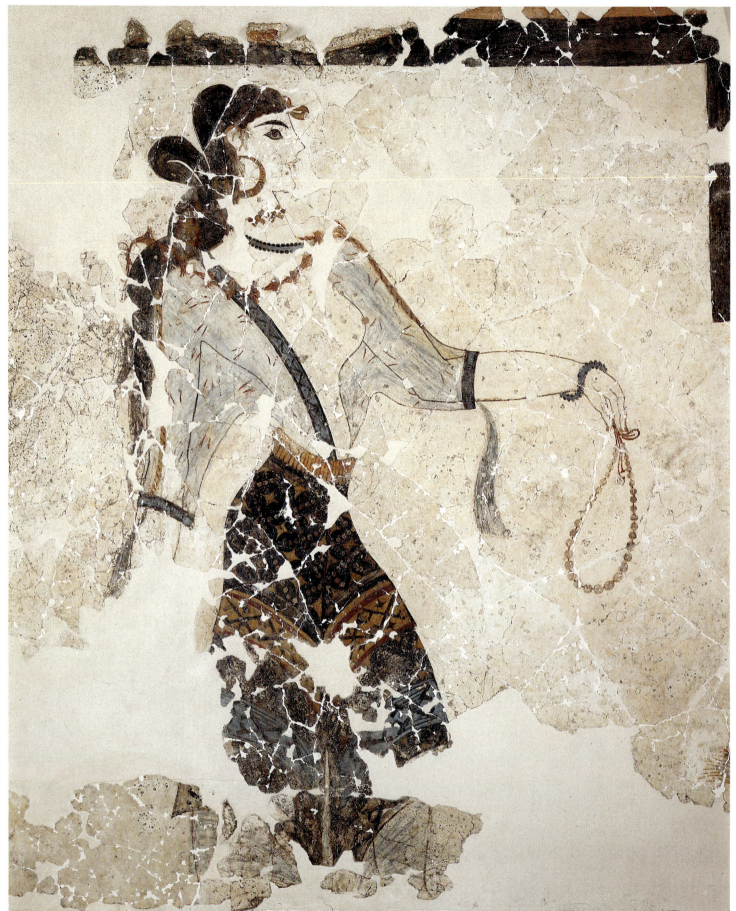

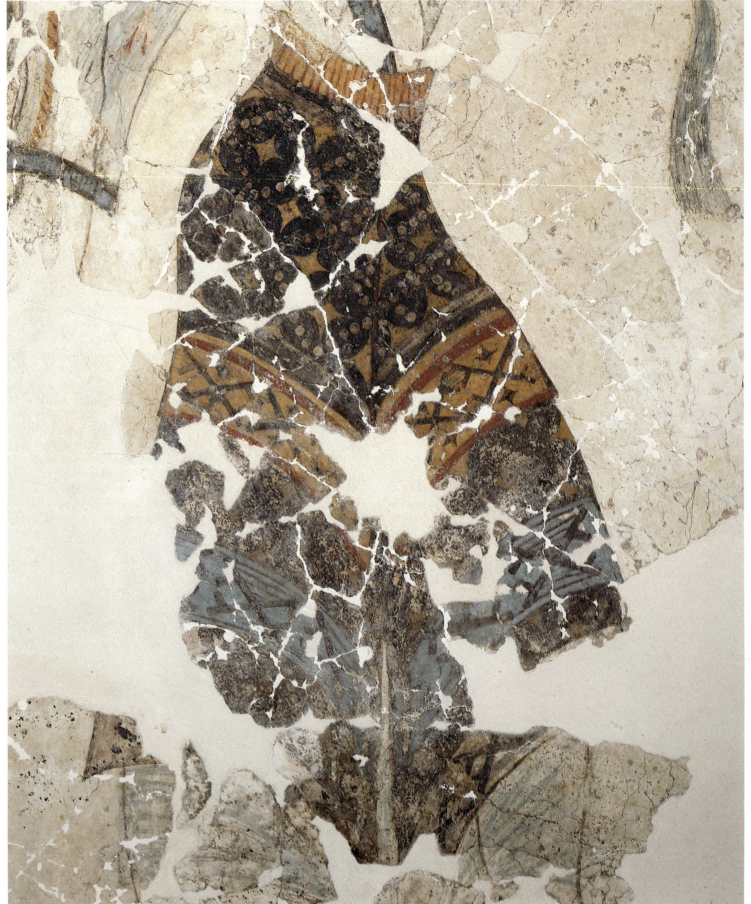

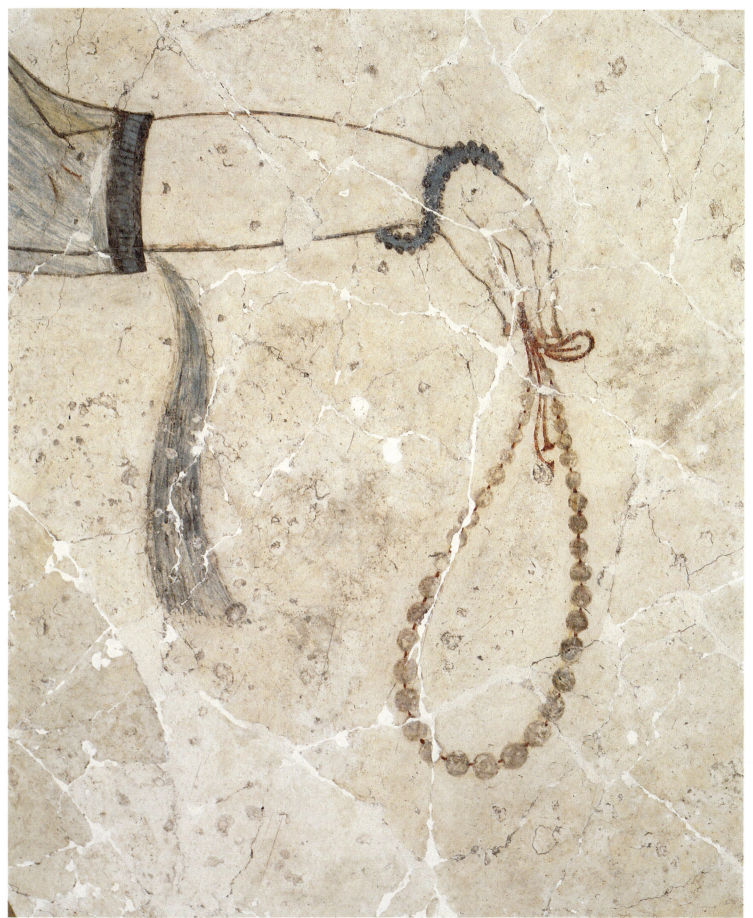

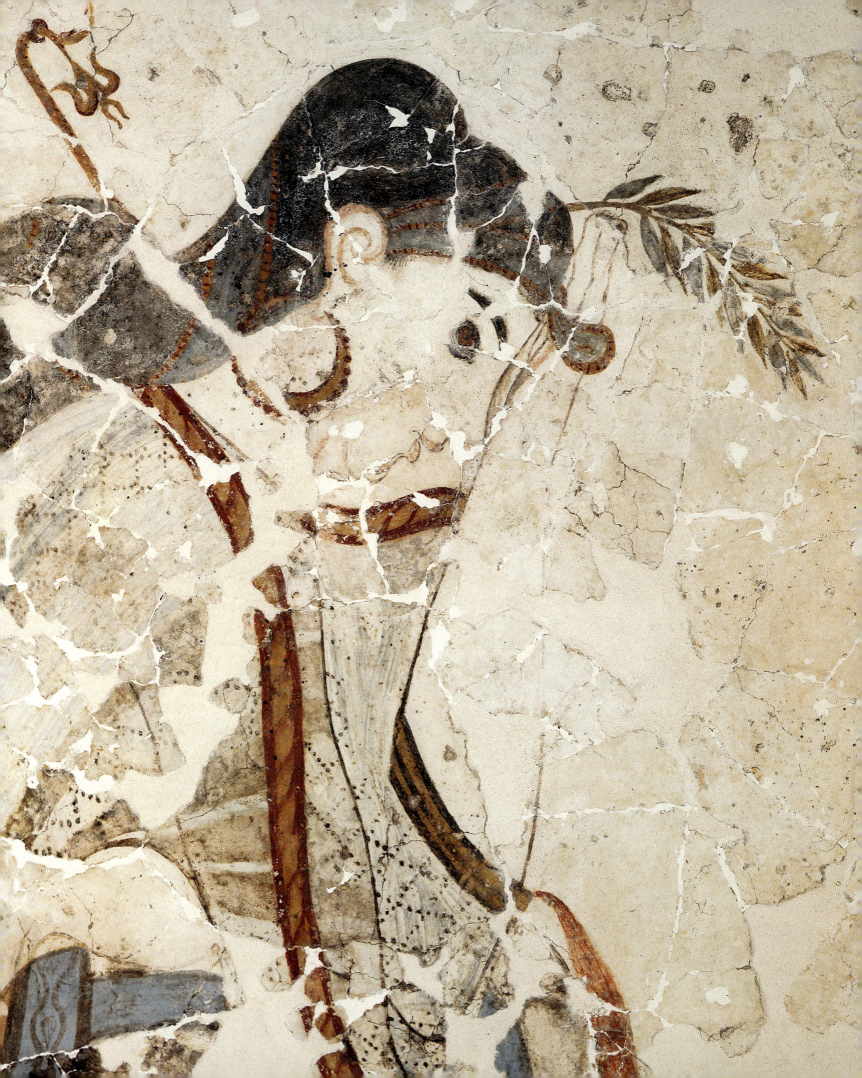

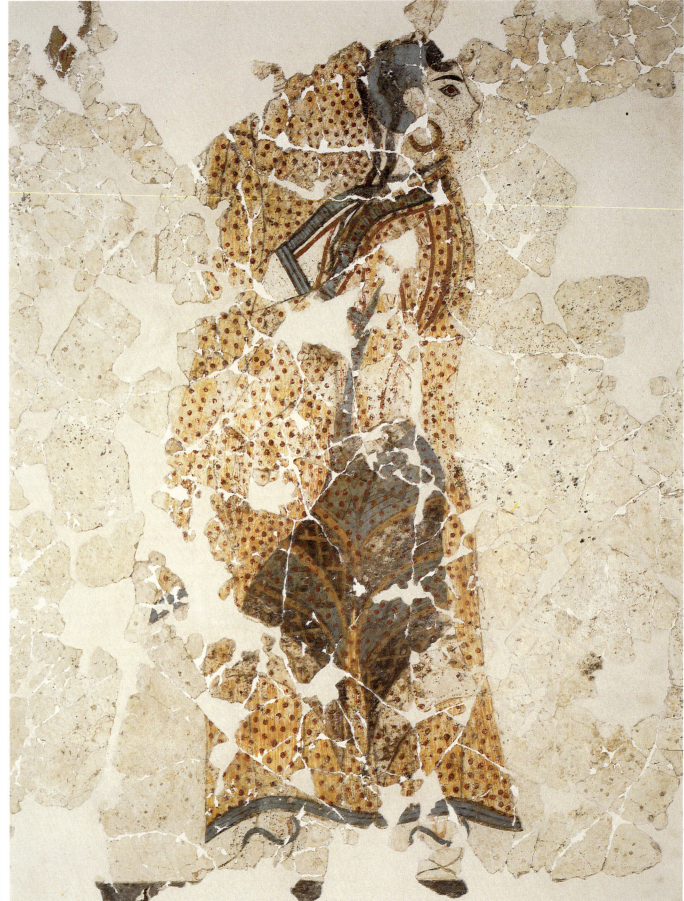

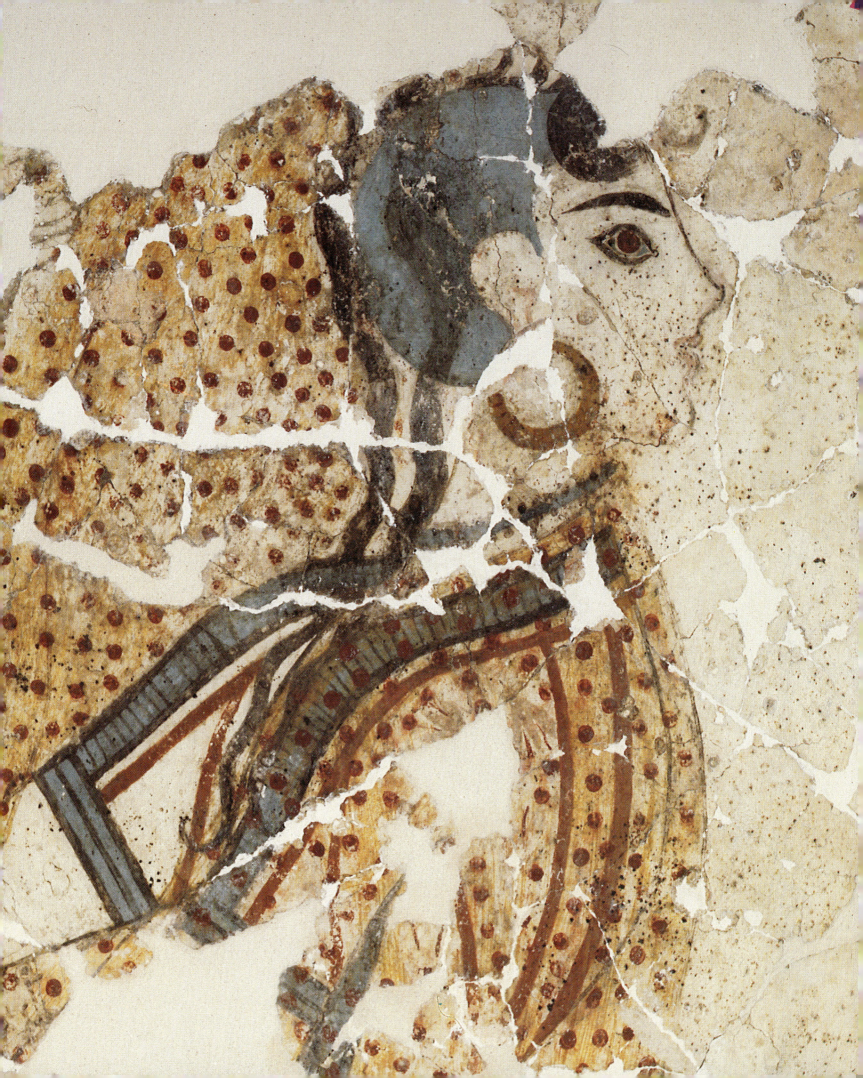

109. Room 3b (ground floor). Middle corridor: Naked Boys.
H. 1.92, W. 1.93 m.

110. Room 3b (ground floor). West wall: Adult Male.
H. 1.93, W. 1.82 m.

111. Room 3b (ground floor). North corridor: Naked Boy.
H. 1.75, W. 1.24 m.

112-115. Details.

109

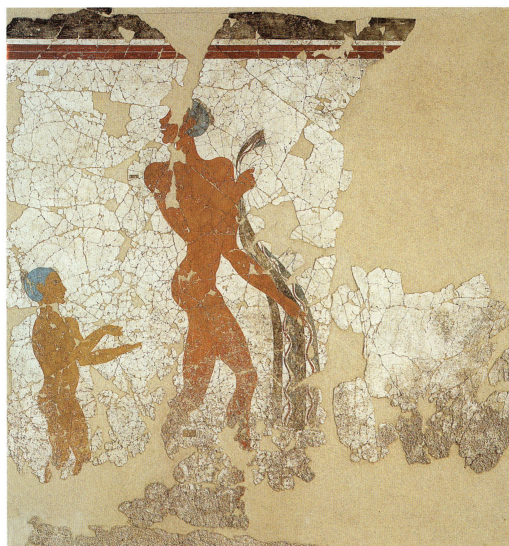
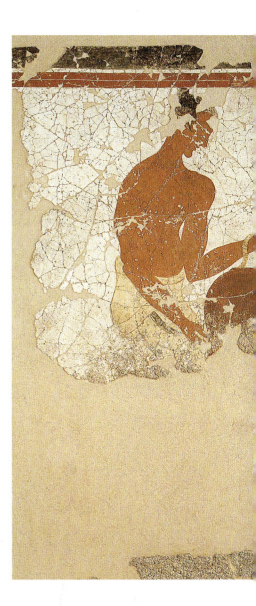

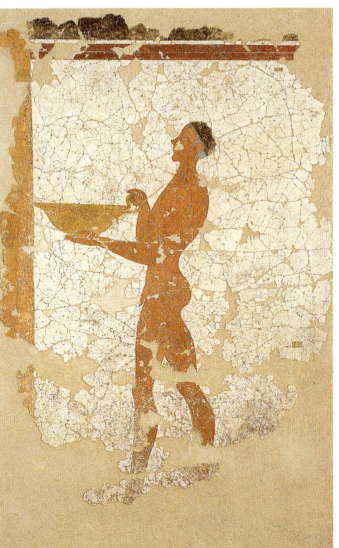

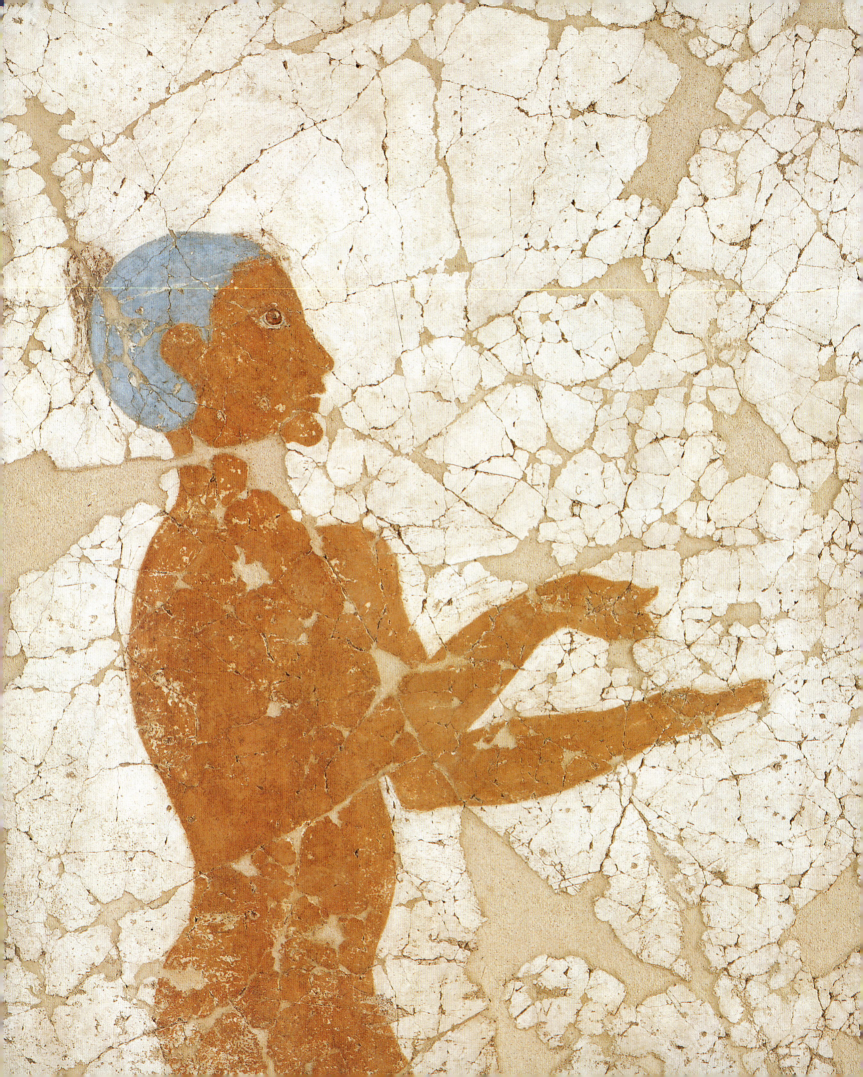

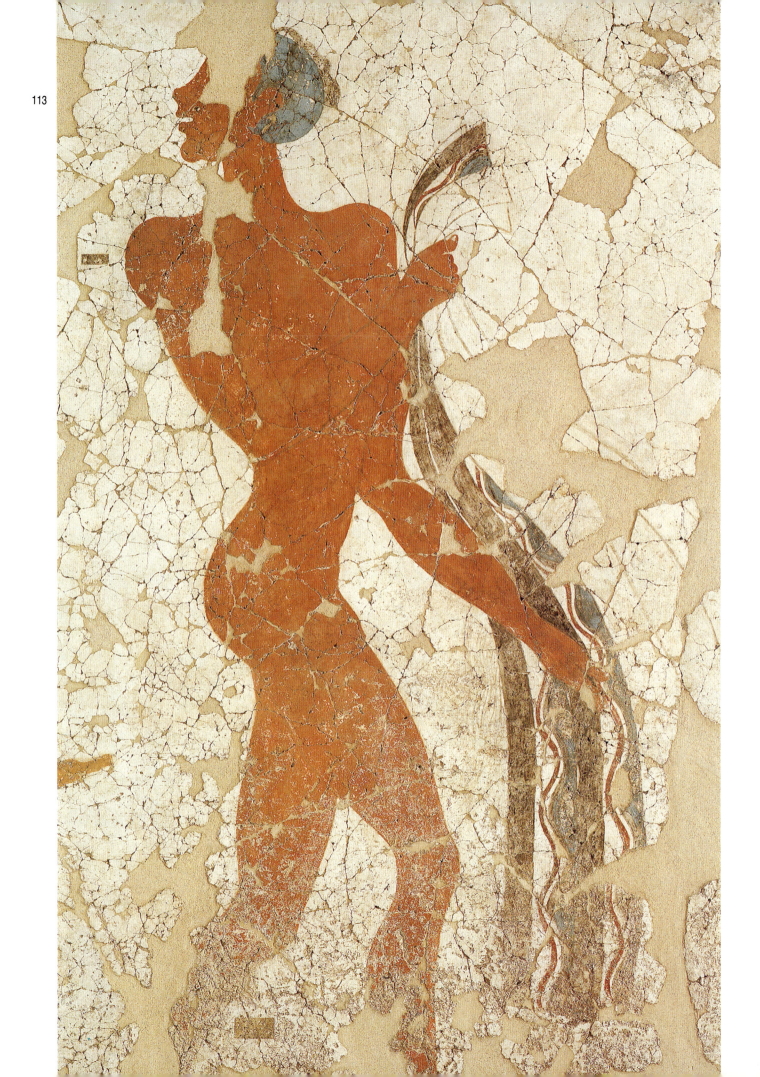

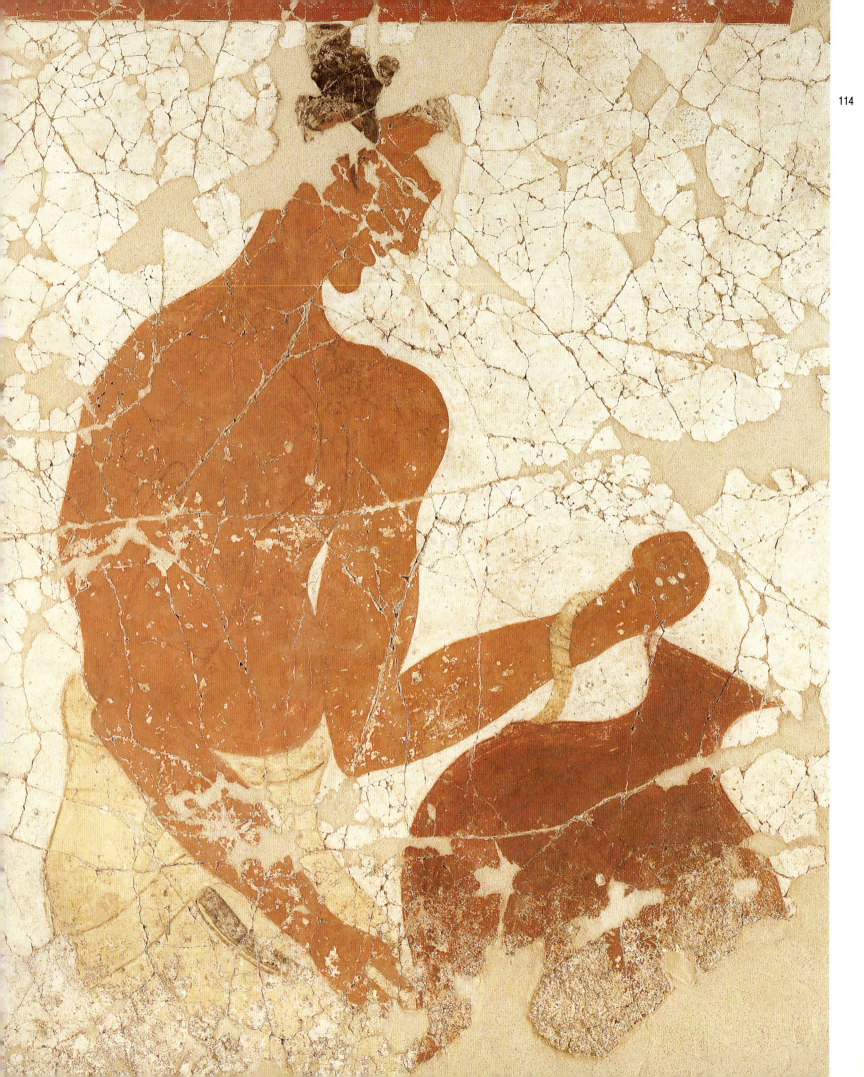

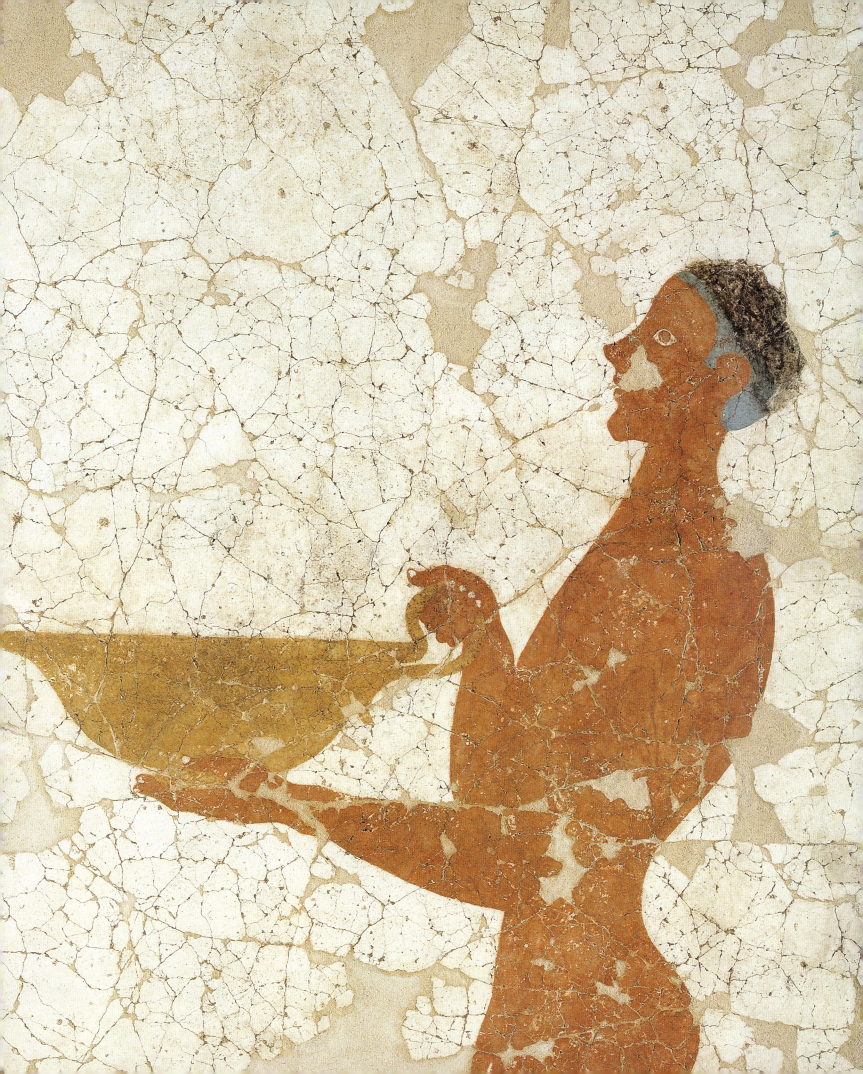

116. Room 3a (first floor). East wall: Saffron-gatherers. H. 2.44, W. 2.66 m.

117-121. Details.

116

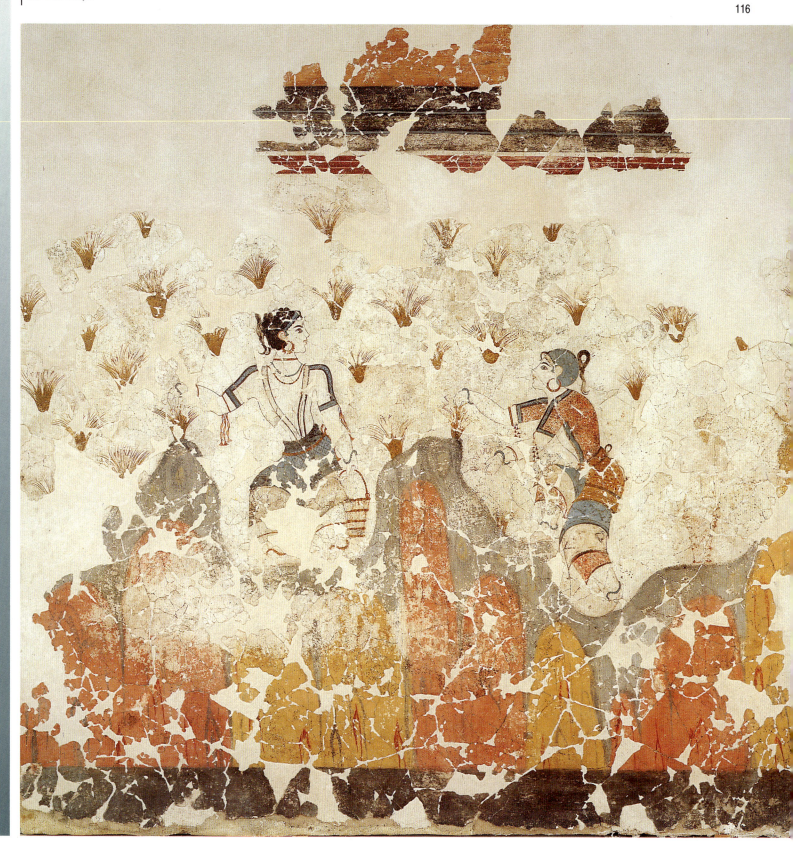

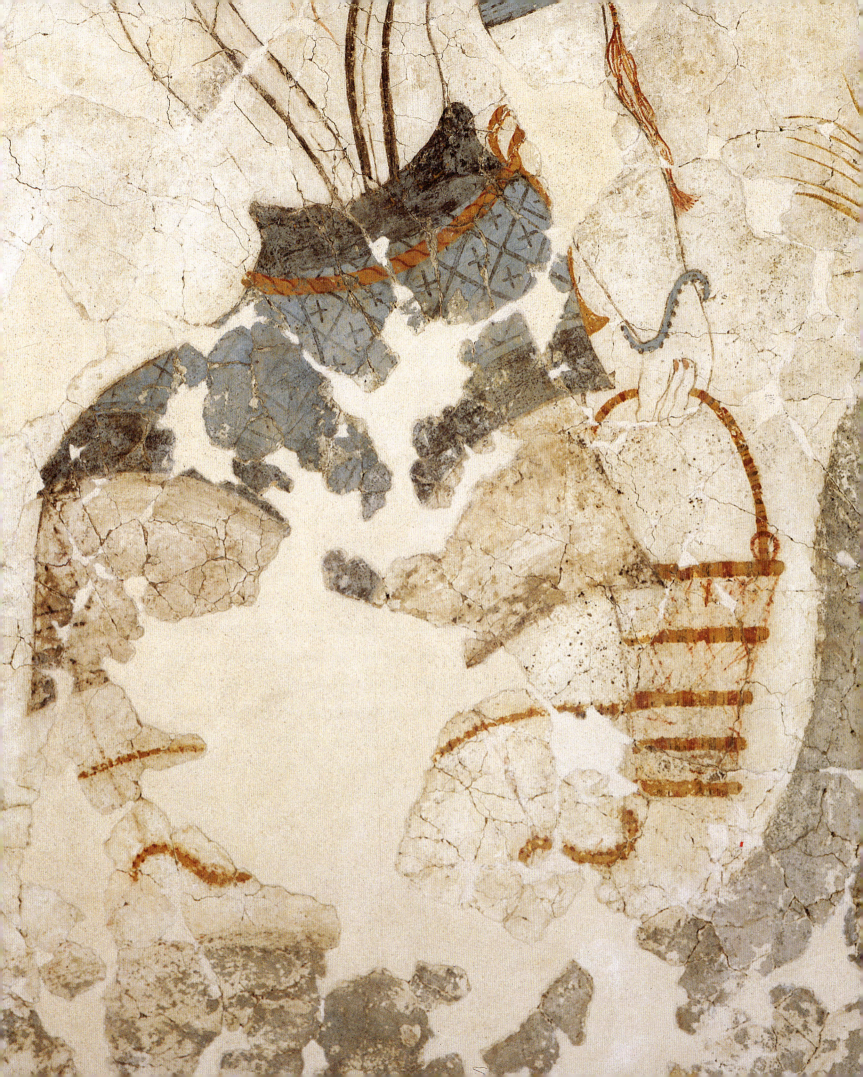

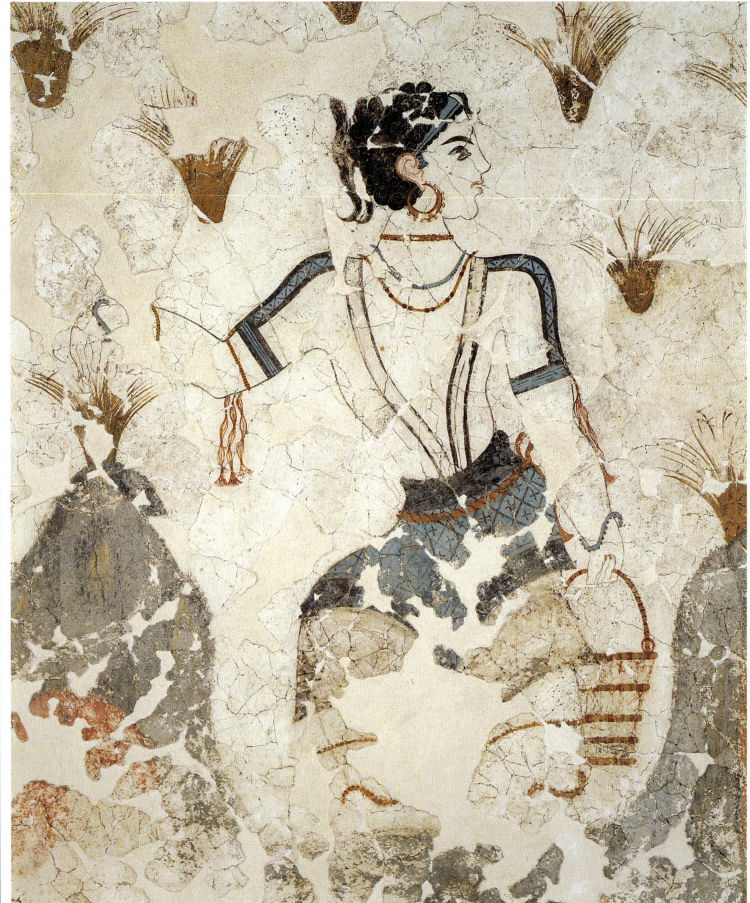

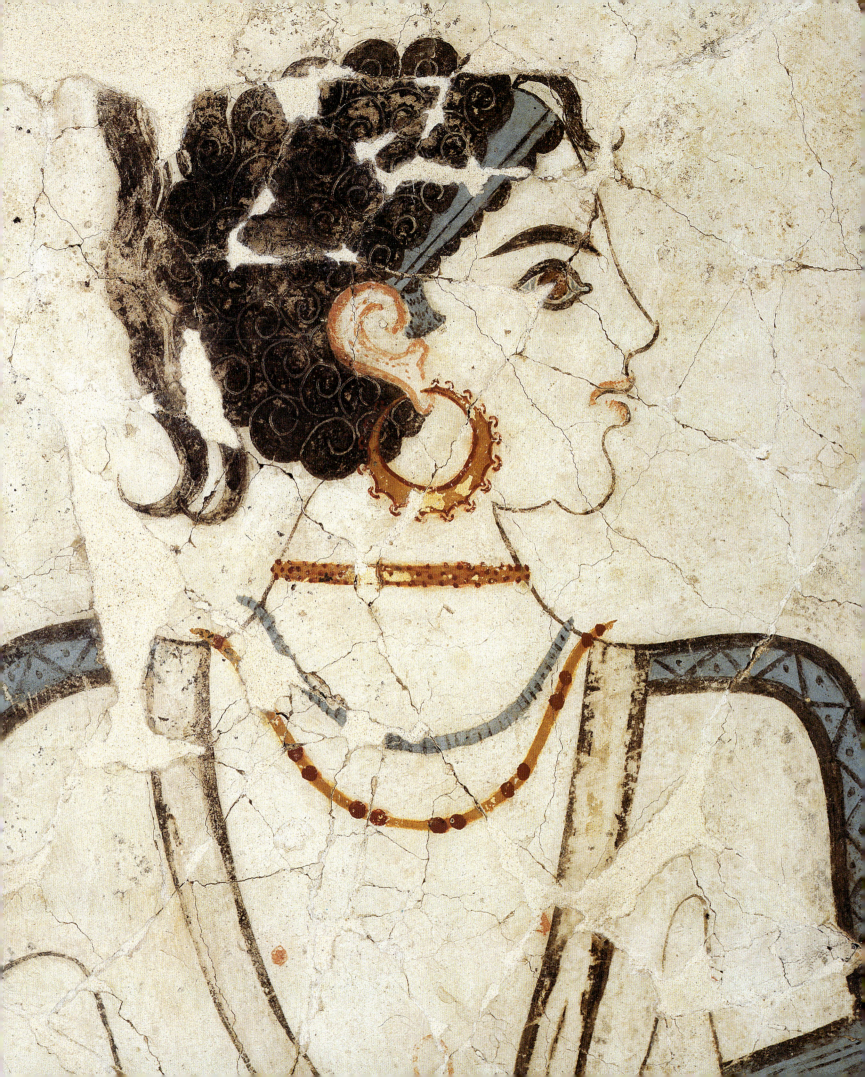

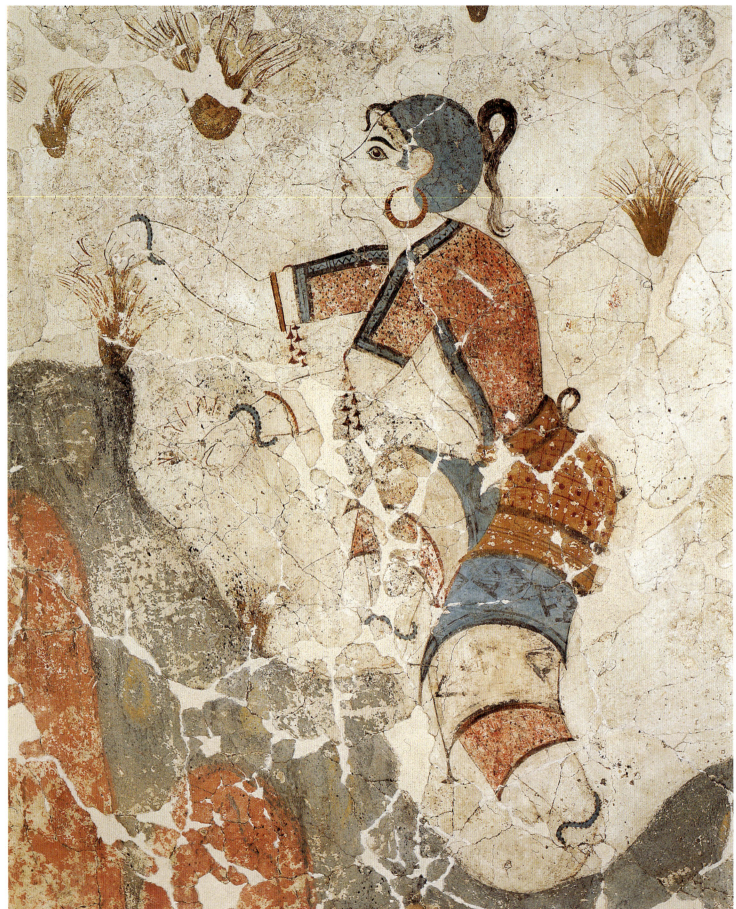

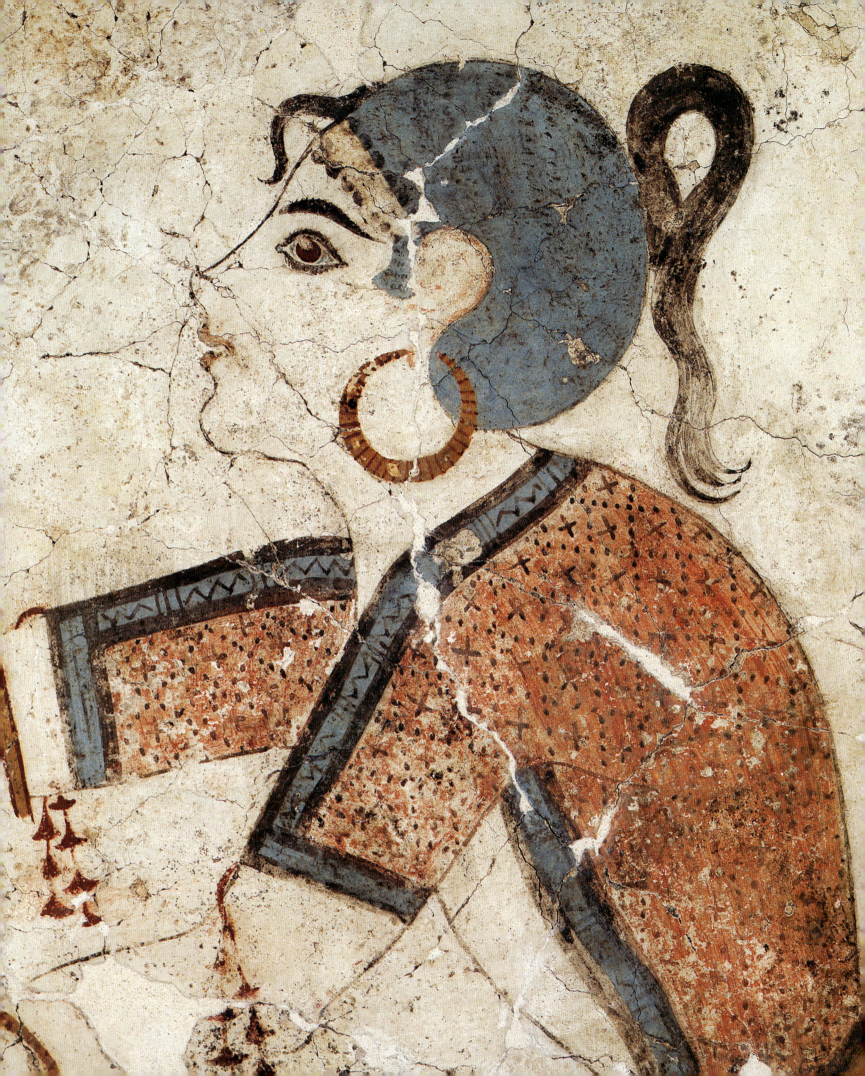

122. Room 3a (first floor). North wall: 'Mistress of Animals' and Saffron-gatherer. H. 2.30, W. 3.22 m.

123-128. Details.

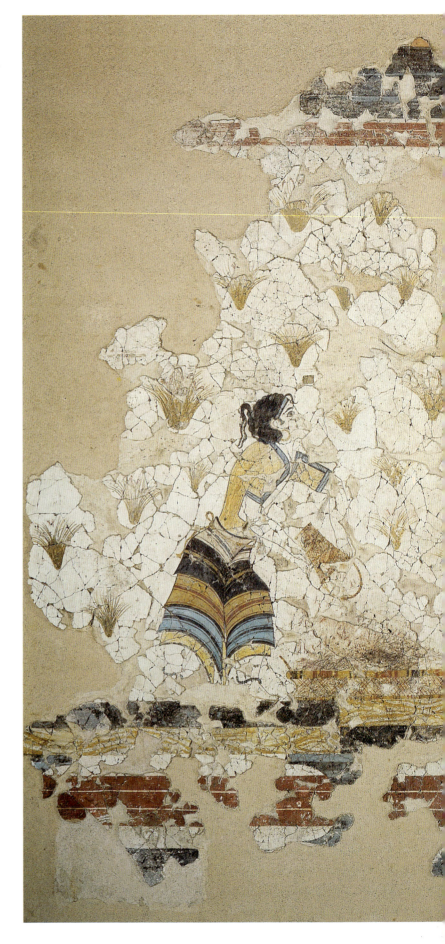

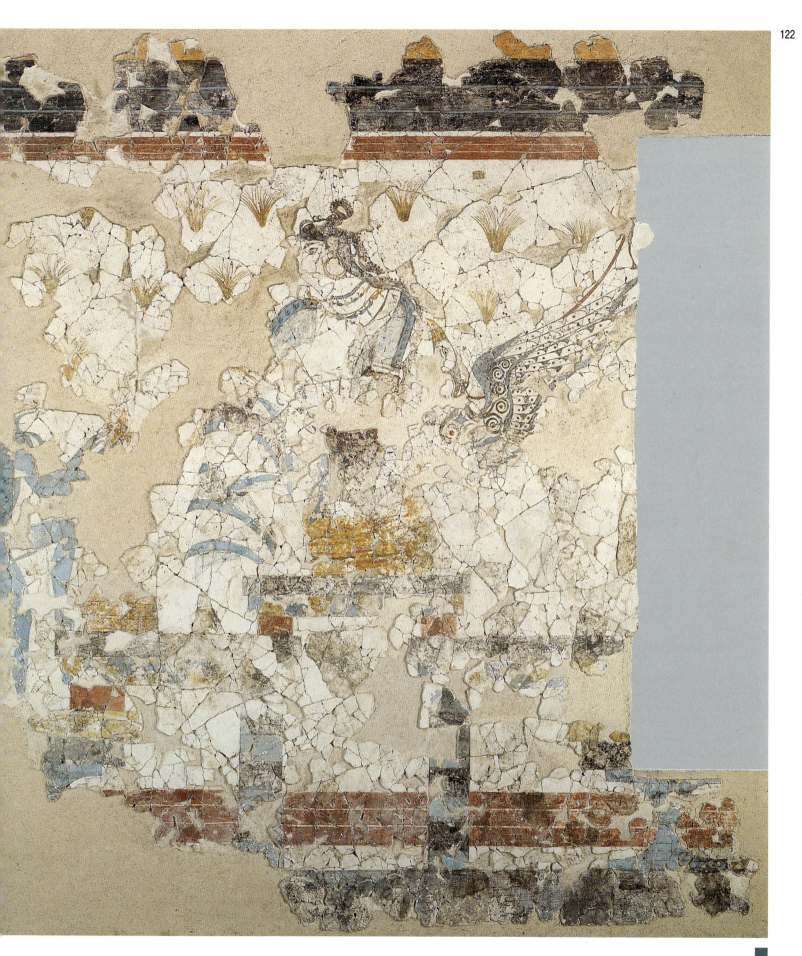

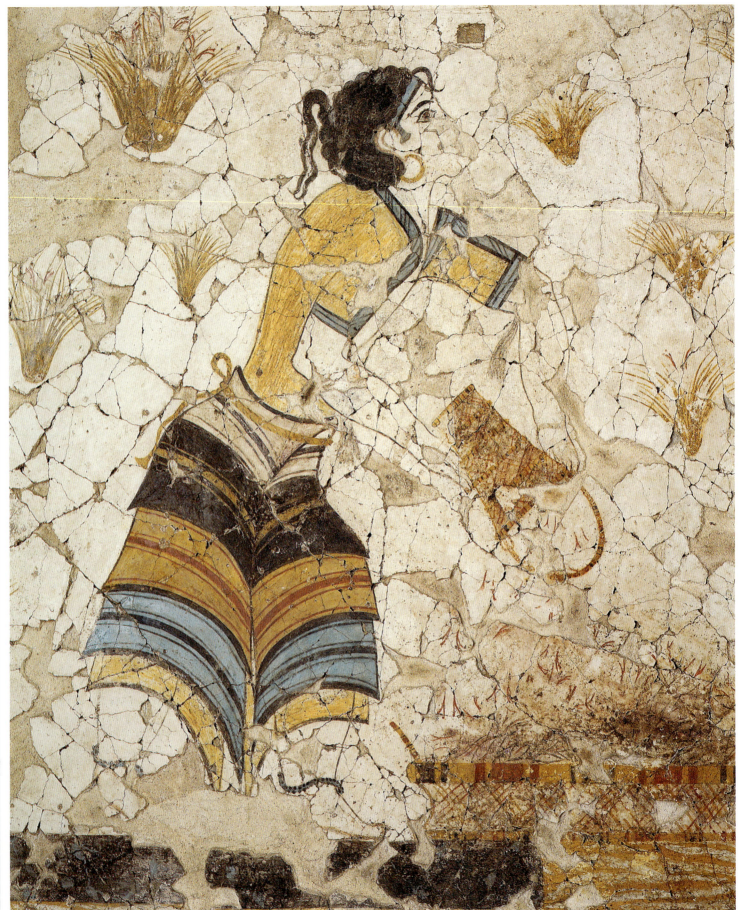

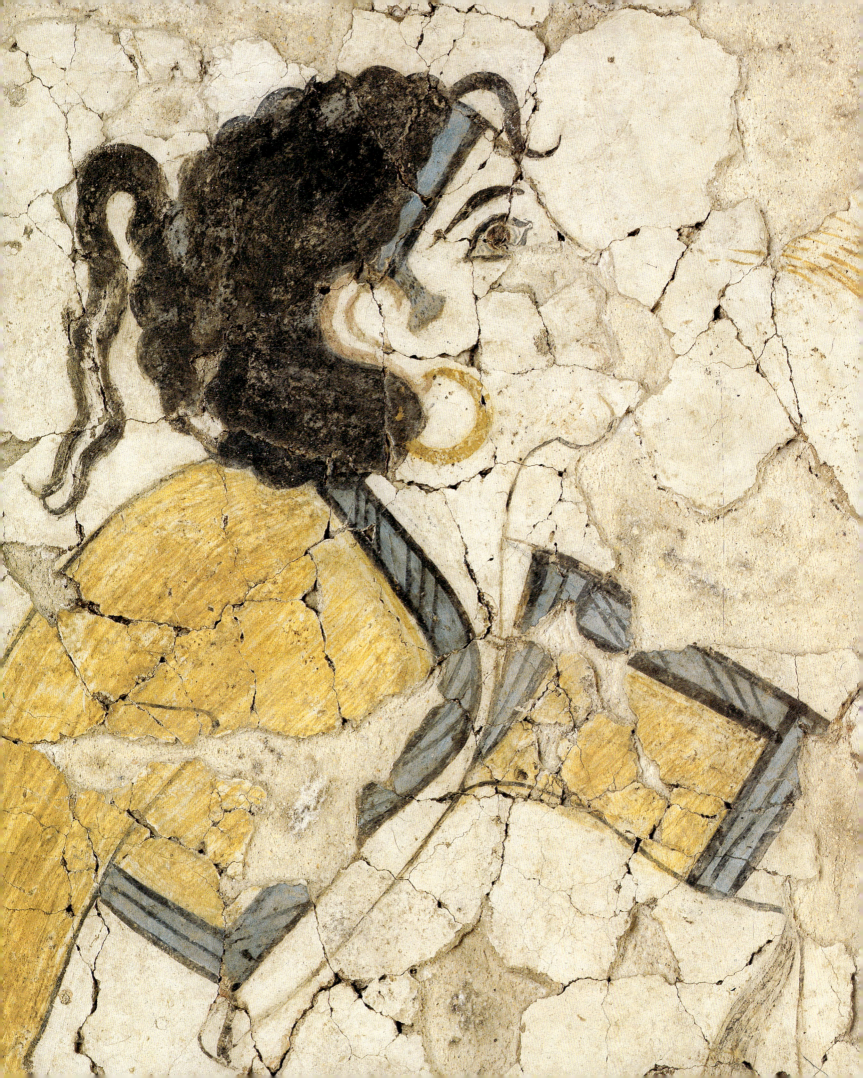

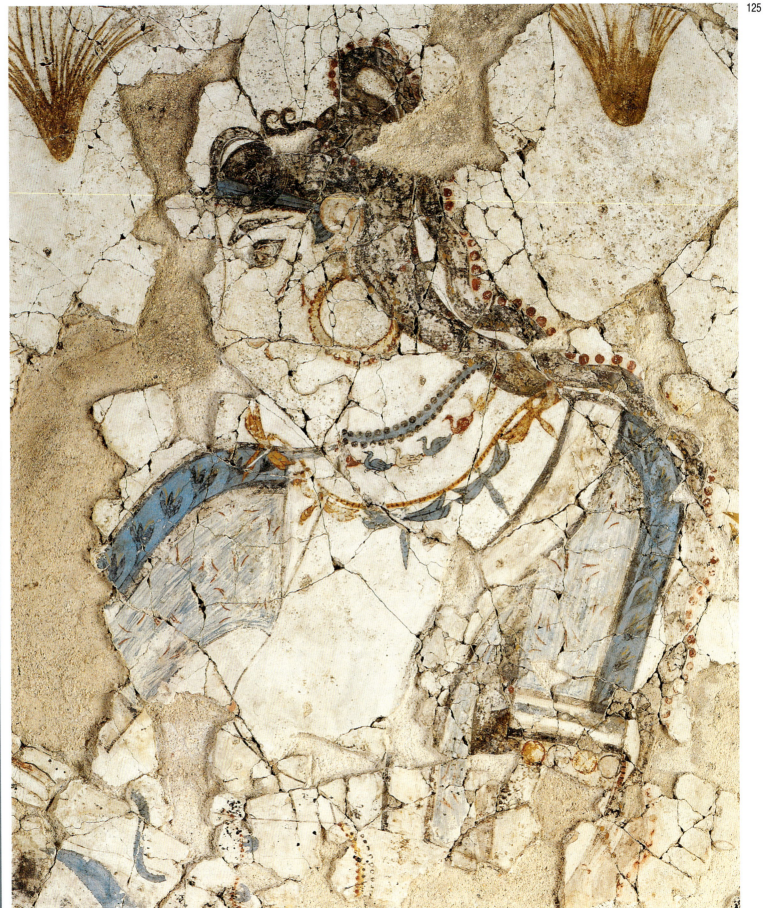

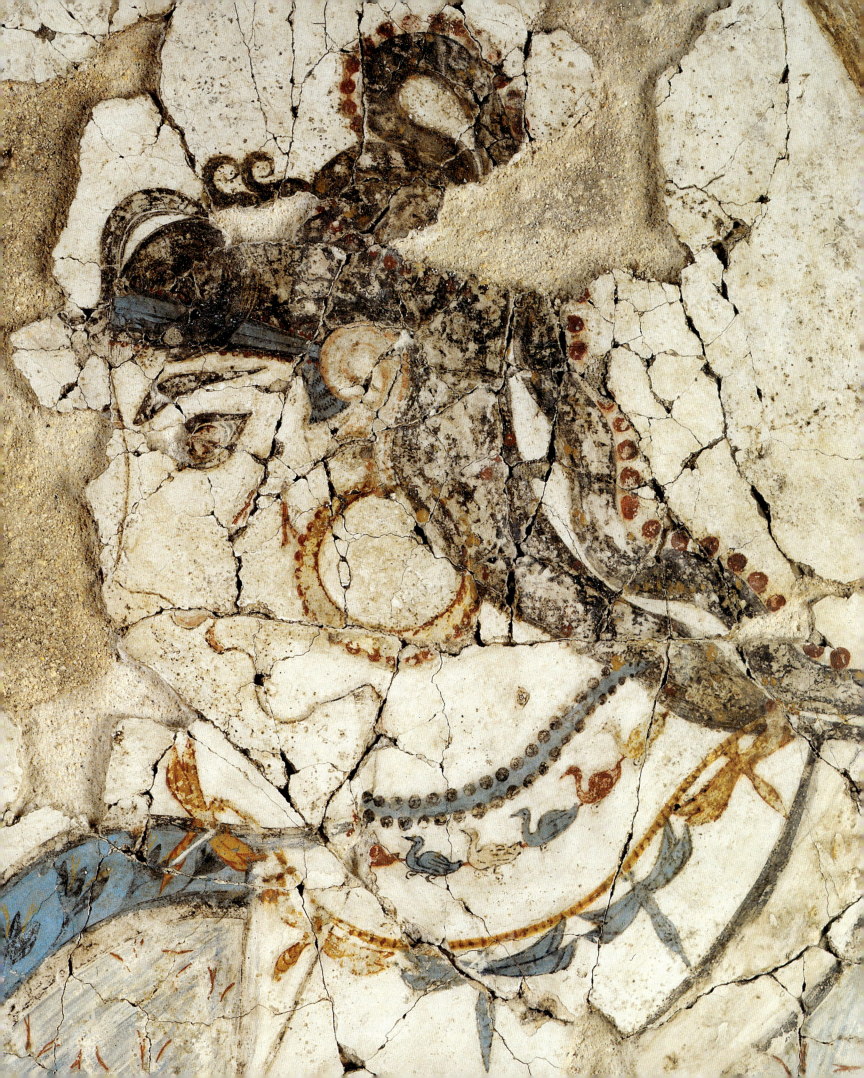

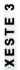

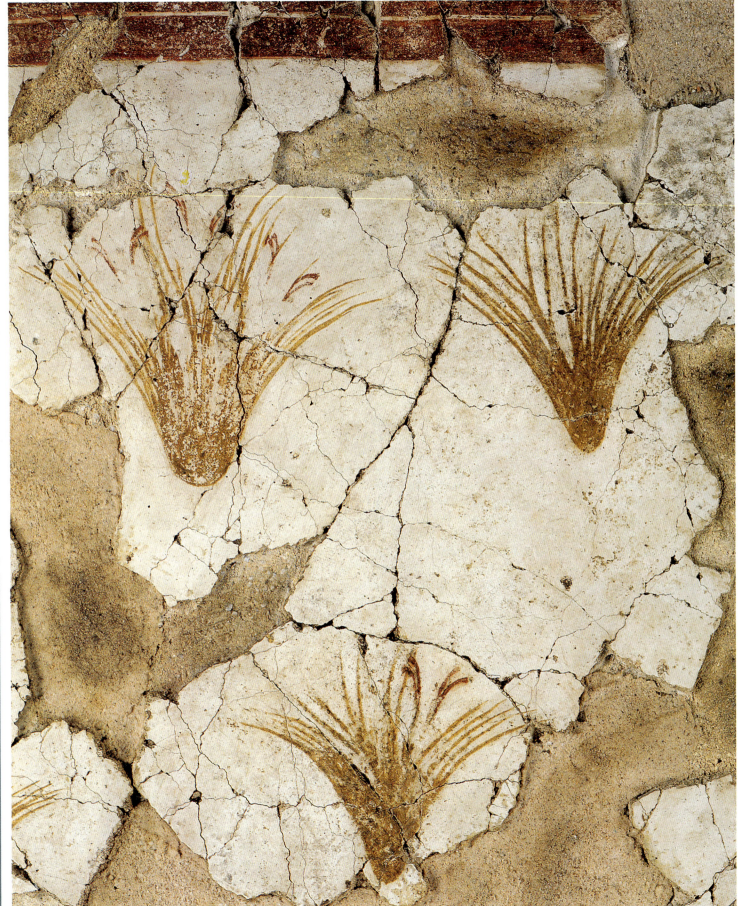

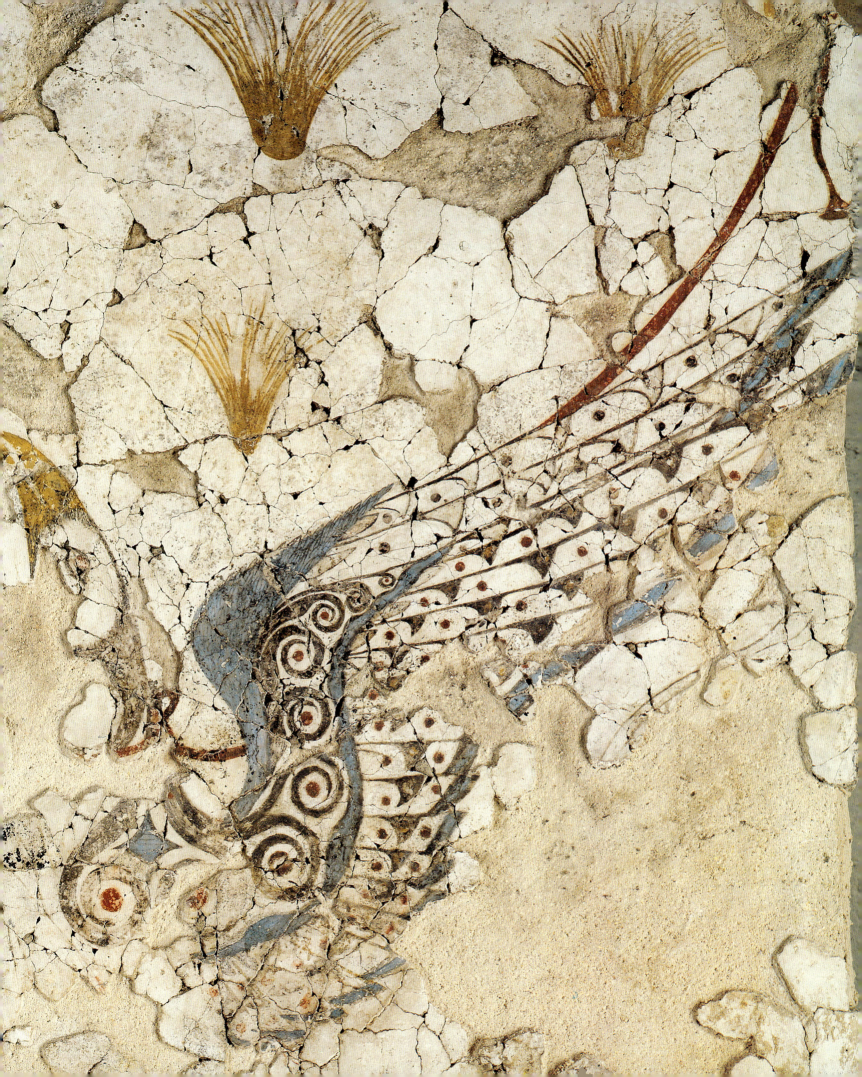

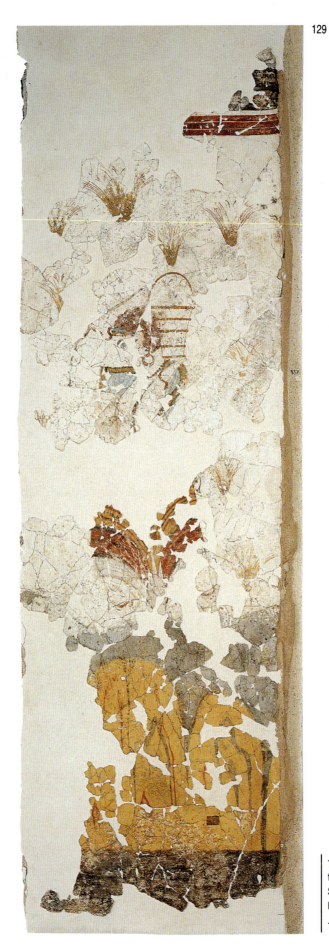

129

129. Room 3a (first floor). North wall: Saffron-gatherer. H. 2.17, W. 0.69 m.

130. Detail.

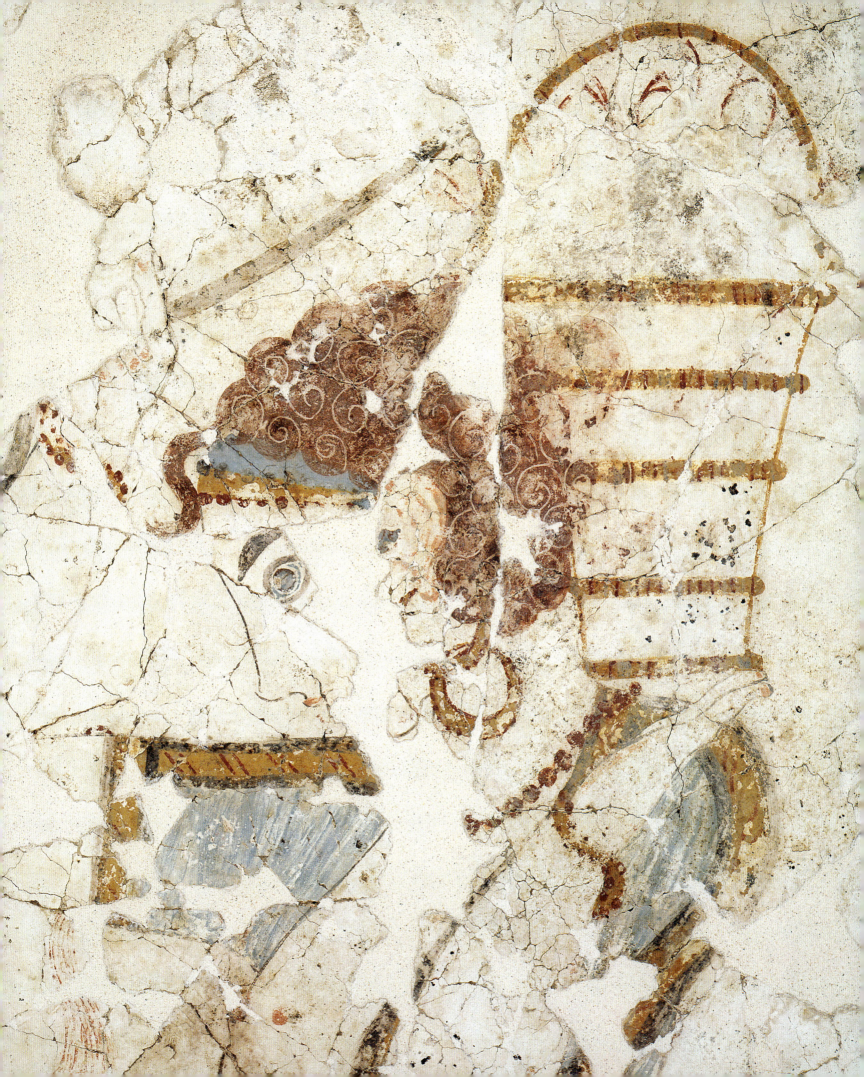

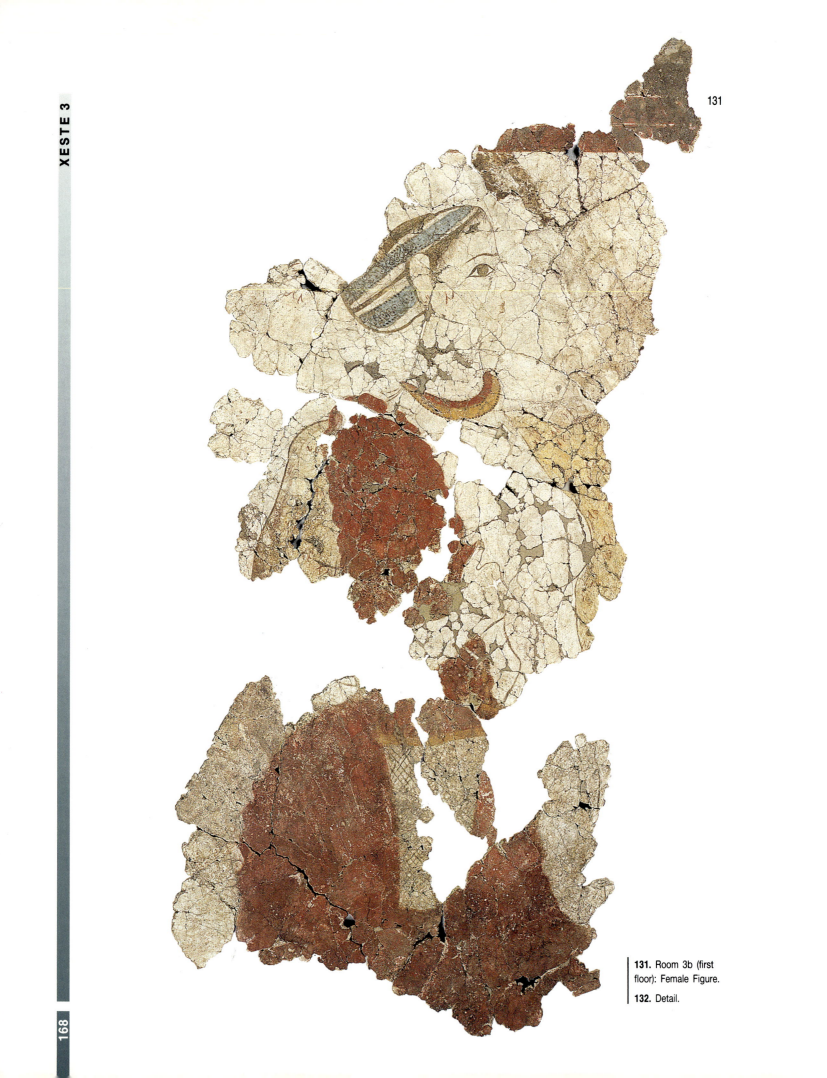

131. Room 3b (first floor): Female Figure.

132. Detail.

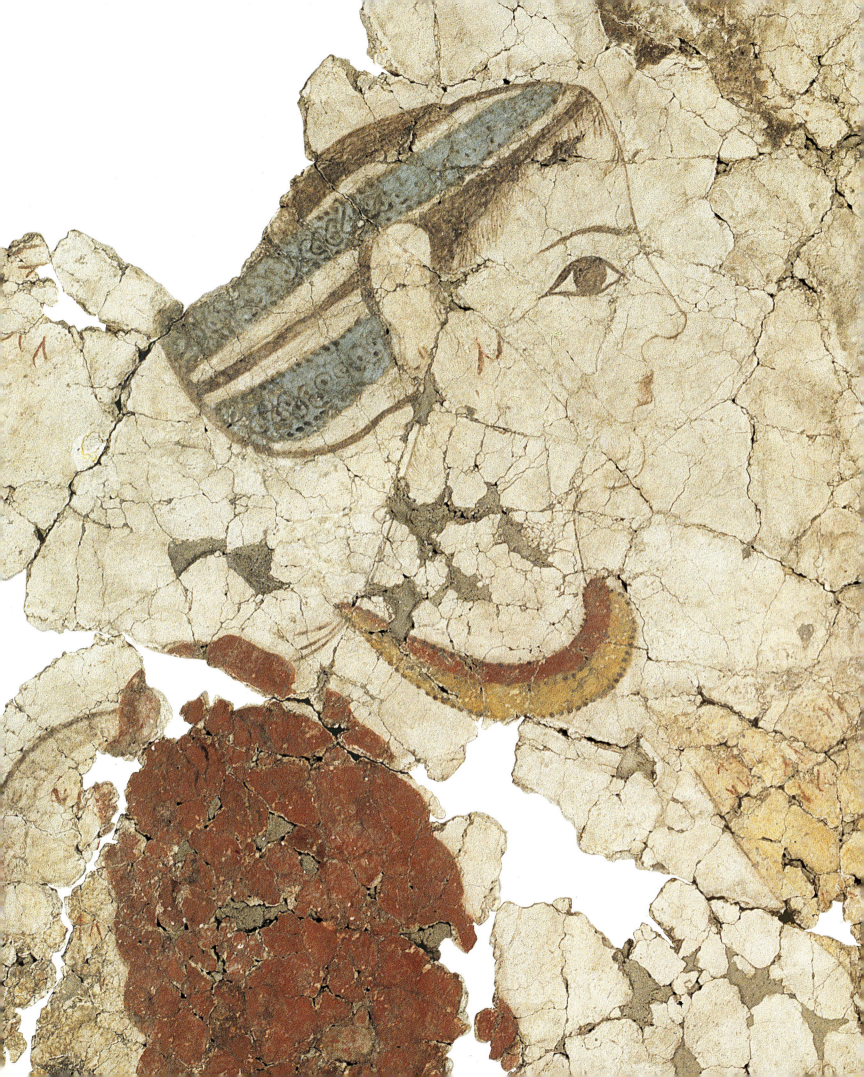

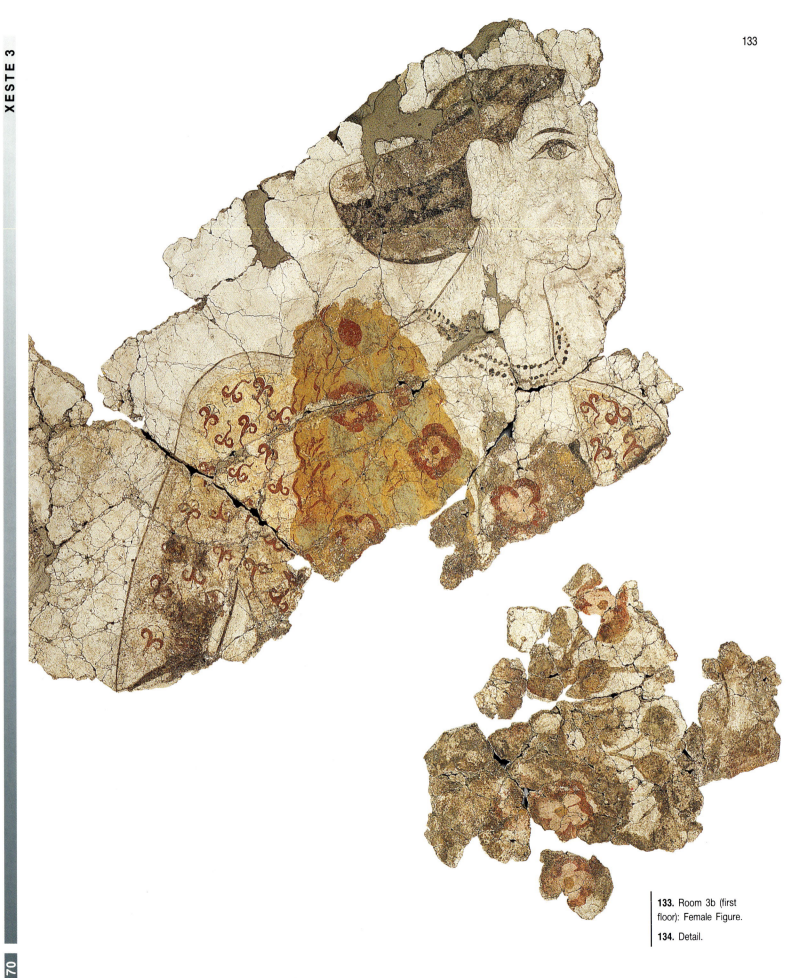

133. Room 3b (first floor): Female Figure.

134. Detail.

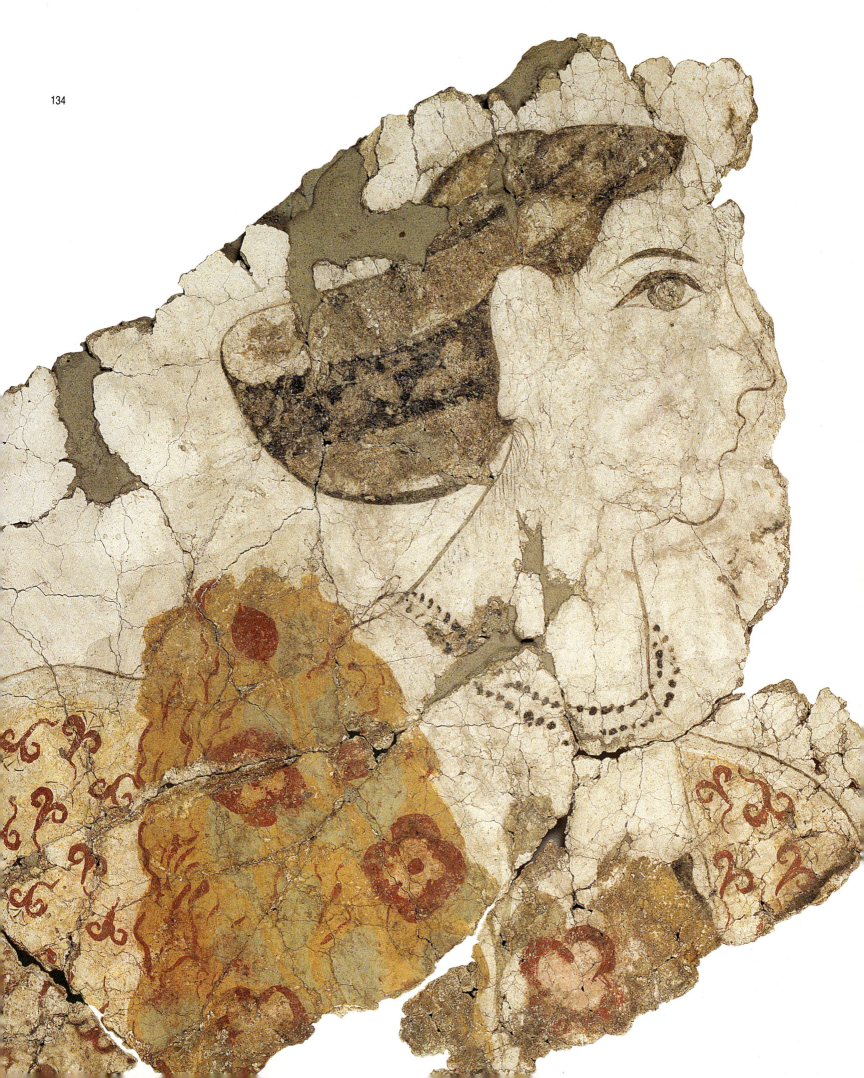

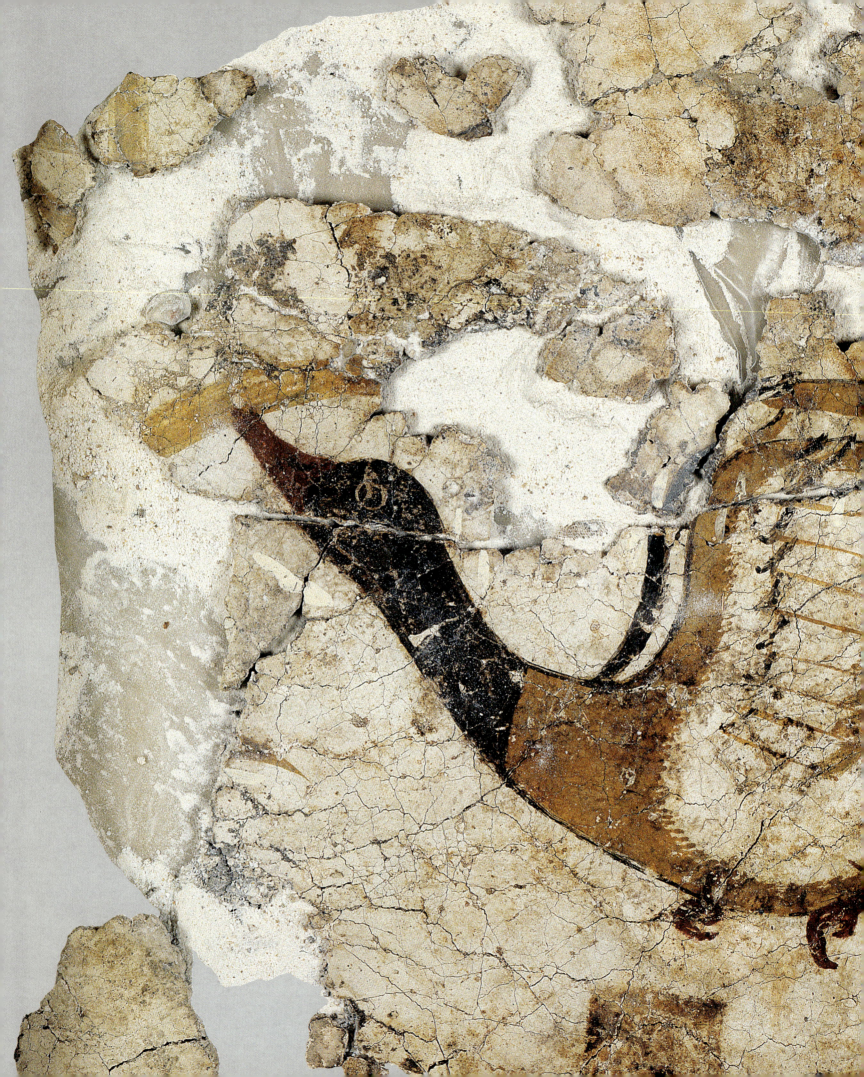

135. Room 3b (first floor): Wild Duck.

136. Room 9 (second floor): Rosettes.
H. 1.91, W. 2.52 m.

137. Detail.

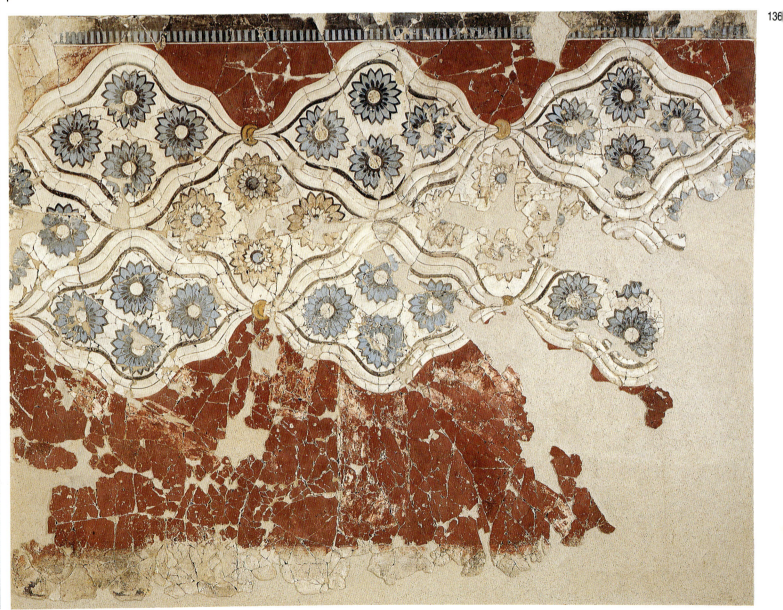

136

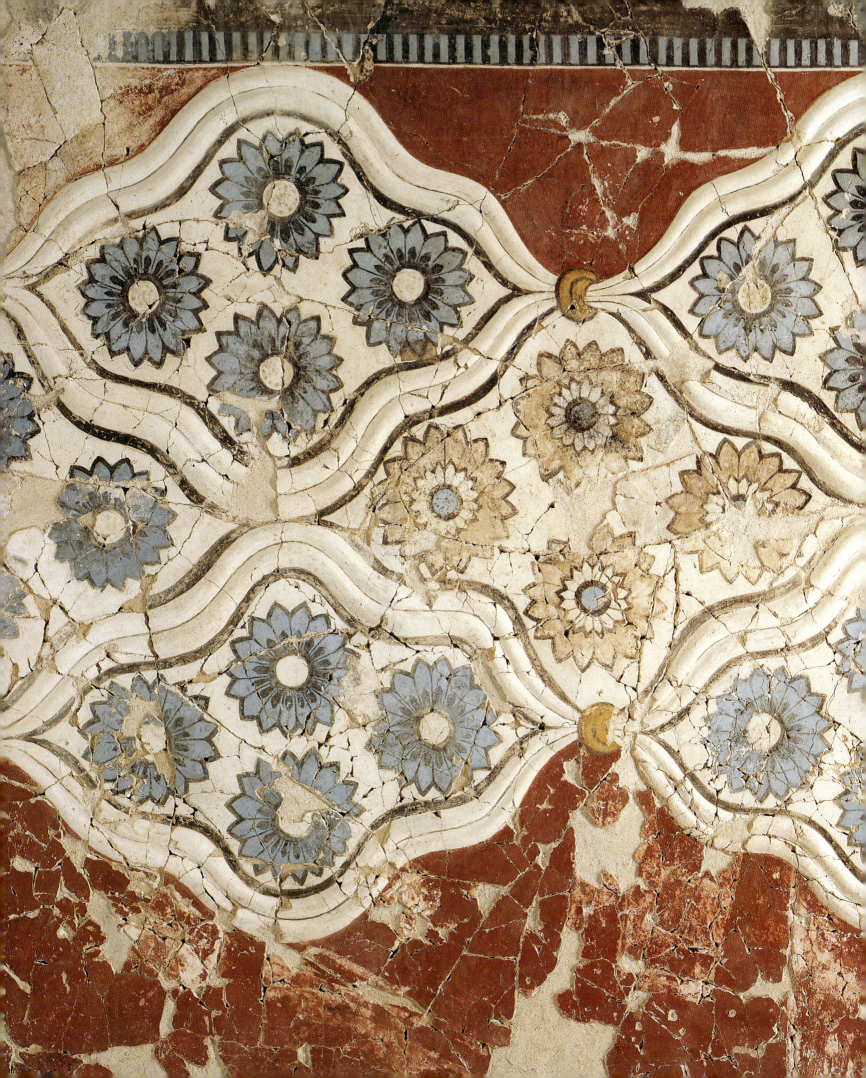

XESTE 4

Marinatos devoted the fateful 1974 season at Akrotiri to the exploration of Xeste 4.[125] This three-storey building was in all probability a public edifice, judging from its unusually large dimensions, its impressive exterior – all the walls are revetted with rectangular ashlar blocks – and its rich mural decoration. Excavation is still in the preliminary stages and it is not possible to derive any conclusions on the building's interior arrangement and the moveable finds.

Unfortunately, inadequate documentation of the finds from the 1974 excavation season[126] prevents us from forming an accurate picture of the exact provenance of the wall-paintings and, even more so, the iconographic programme of the building. However, the few fragments mended so far seem to belong to a composition which adorned the walls on either side of a staircase, depicting virtually life-size male figures ascending the steps in procession.[127] Almost certainly resumption of work in Xeste 4 will reveal further fragments, which will help complete the composition and thus aid its better understanding.

138

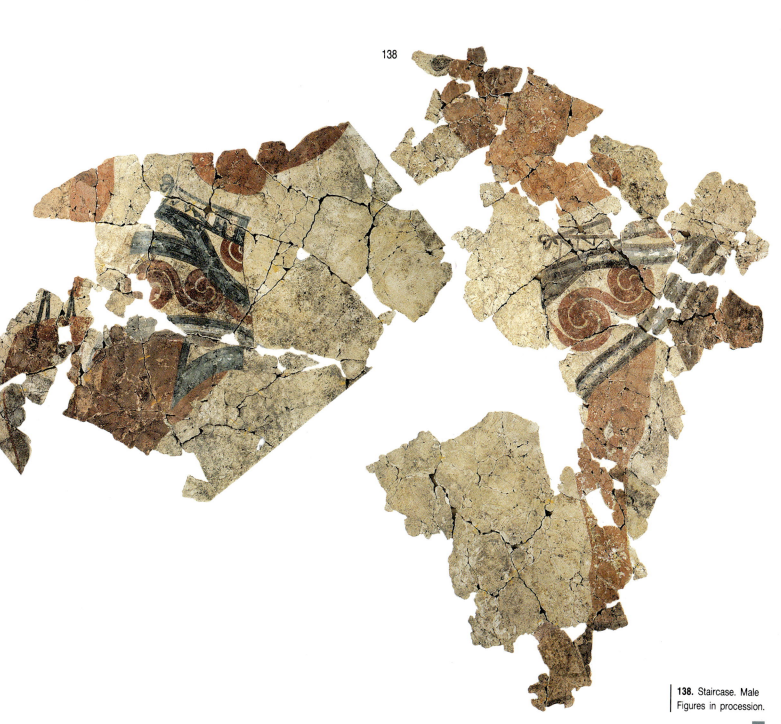

138. Staircase. Male
Figures in procession.

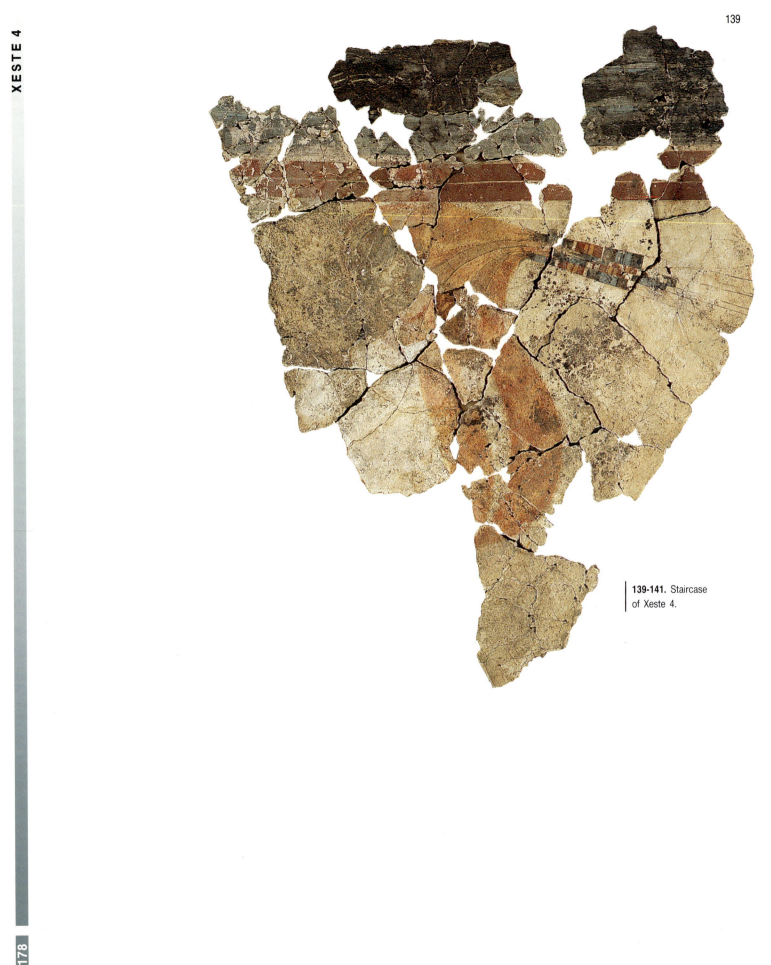

139-141. Staircase of Xeste 4.

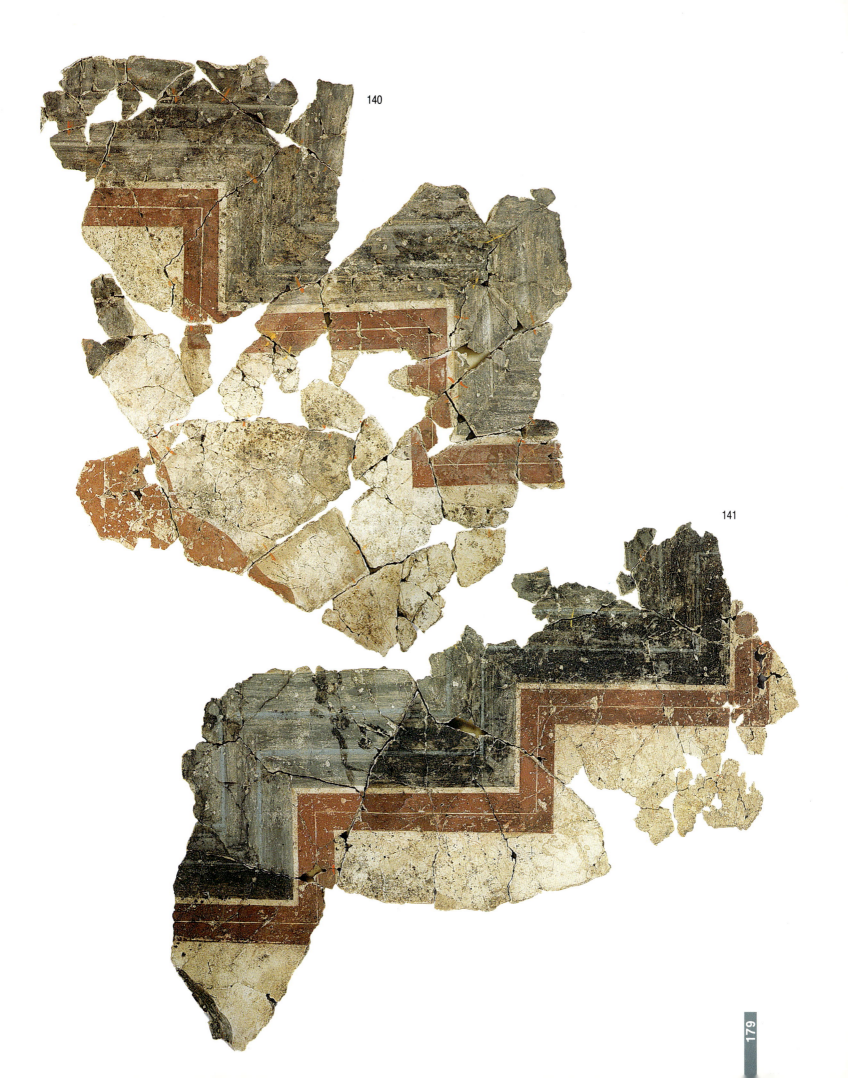

140

141

PORTABLE WORKS OF ART

A special category of vessels, known as 'tripod offering tables', are normally of fired clay. At Akrotiri, however, there are several examples made from lime plaster, covering a core of unfired clay. The upper surface is concave and usually painted reddish brown. On those examples where there is other decoration this covers the vessel's external vertical surfaces, is executed in wall-painting technique and usually includes linear designs and only rarely pictorial compositions. Though these vessels are generally regarded as being of religious significance, neither their find spot nor their context, at Akrotiri at least, confirms or negates this opinion.

The offering table found on the sill of the southernmost first-floor window on the facade of the West House, protected by a large, upturned clay vase, is in exceptionally good condition.[128] Its unique preservation and rich pictorial decoration make it one of choicest portable works of Theran art. The concave upper surface is painted a reddish brown which extends over the horizontal rim in the form of the 'silent wave' motif. The entire external surface of the vessel and its legs are covered by a unified composition of a marine theme. Representations of rocks with forked tongue-like edges form the frame for the underwater setting in which the artist painted three dolphins in each of the 'spandrels' above the legs of the vessel. Although this frame follows the Cretan principle of the representation of 'hanging rocks',[129] the manner in which the dolphins are portrayed displays closer affinities with the Egyptian principle according to which 'trees set round a pond spring from it at right angles so as to appear upright at the top, but sideways or upside down elsewhere.'[130] The only difference between the dolphins and the Egyptian trees is that the former are portrayed inside the frame, moving parallel with it. Thus the representation has three optical angles, that is as many as its sides.

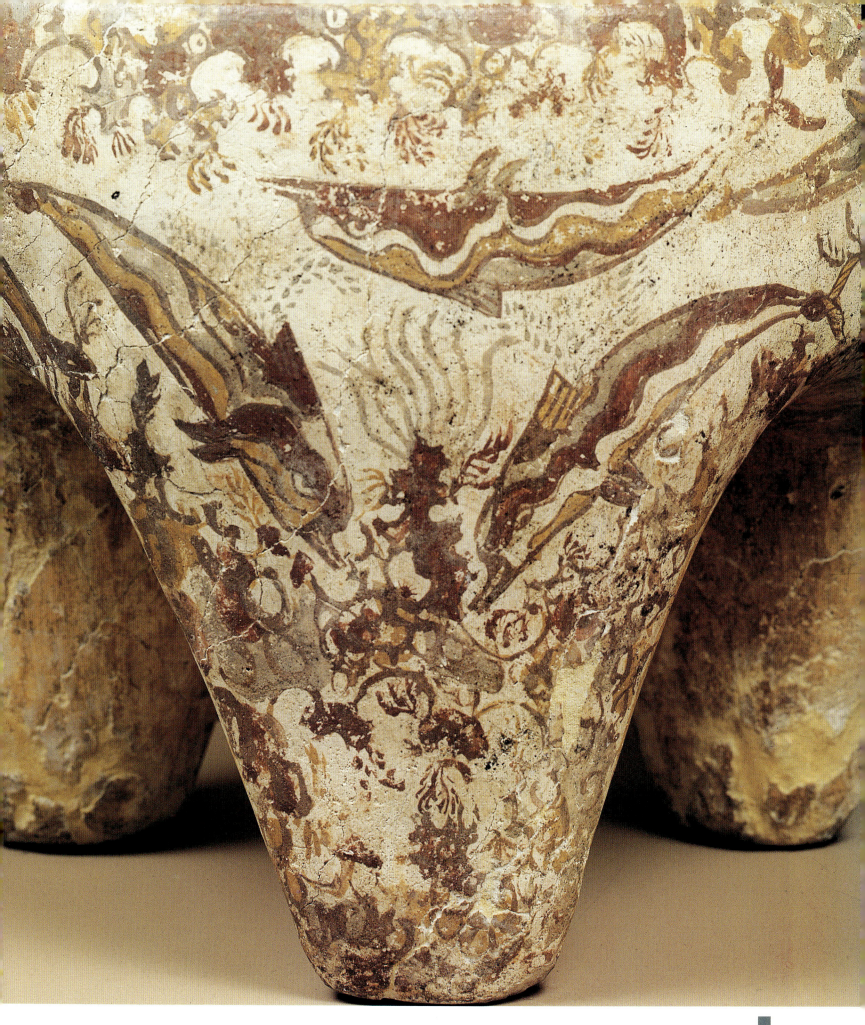

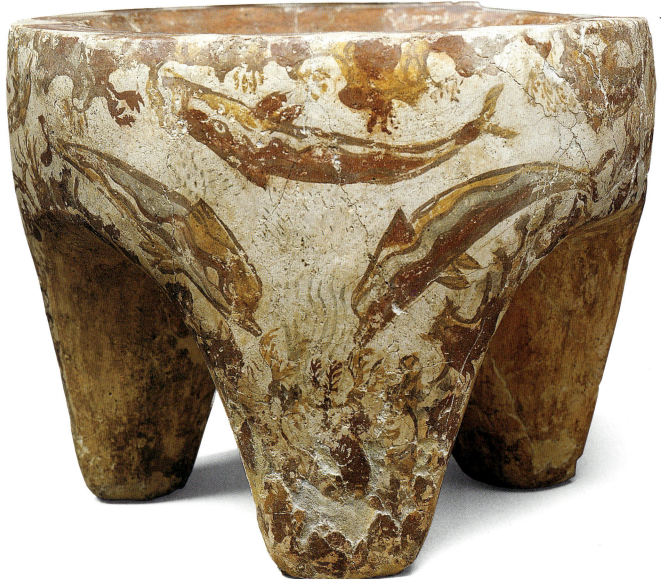

143

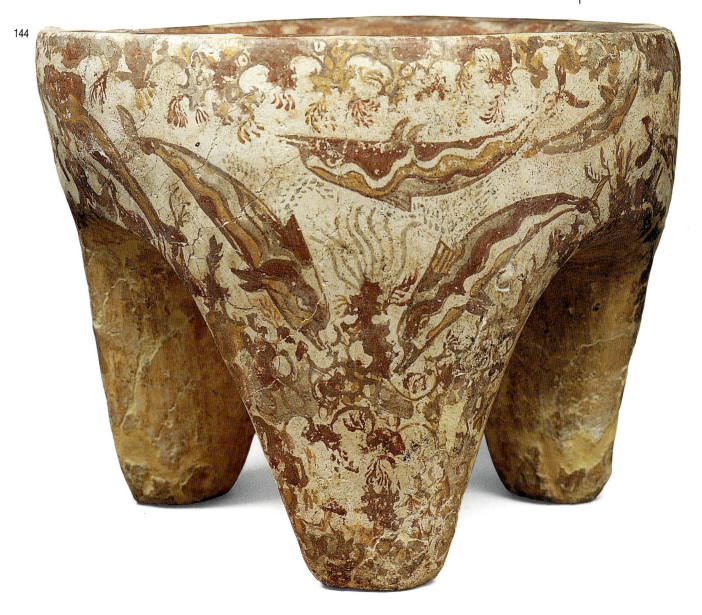

144

142. Detail.

143-144. Tripod offering table from the West House. H. 0.30, Diam. 0.289 m.

FRAGMENTS

In addition to the compositions which we can more or less understand, Akrotiri has produced other wall-paintings, of which only fragments are known, either because they have suffered considerable damage or because of the limited extent of the excavation. The fragmentary state of these wall-paintings in no way detracts from their importance, since they verify the almost inexhaustible repertoire of the Theran artists and the artistic interests of their patrons.

AREA OF SECTOR A The winter torrent which flowed through the area of Sector A, known as Arvanitis 1 in the early excavation reports, destroyed a large part of the buildings and undoubtedly contributed to the very fragmentary picture of the wall-paintings which decorated them. These fragments belong to representations with decorative motifs, birds, etc.[131] A noteworthy piece preserves part of an architectural structure (perhaps an altar), crowned by sacral horns. On either side of one of the structure's supporting columns, which Marinatos characterized as being of Egyptianizing form, are sections from the scene of monkeys.[132] Another fragment shows the head of a male figure with markedly African features in front of a palm tree.[133]

AREA OF THE HOUSE
OF THE LADIES A building to the east of the House of the Ladies, which Marinatos characterized

145

145. Spirals from Building Gamma.

146. Swallow from the area of Sector Alpha.

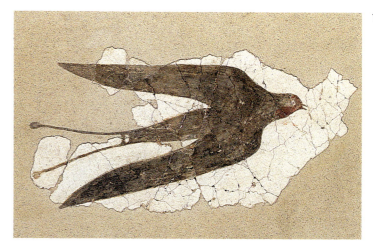

as a 'kitchen', has produced wall-paintings with floral themes and lilies identical with those depicted in Room Delta 2.[134]

AREA OF BUILDING GAMMA

Only those rooms of Building Gamma facing Telchines Street have been excavated – and these only in part. It is evident from the excavation data that these rooms had been badly damaged in the earthquakes prior to the eruption and that those on the ground floor had subsequently been hastily repaired and used by teams clearing the ruins. These interventions account for the fragmentary nature of the wall-paintings found in this area. Fragments with representations of what appear to be decorative motifs were recovered from Room Gamma 1, as was a section depicting an intricate combination of spirals and plant motifs, which seems to have belonged to a frieze.[135]

Fragments from a composition depicting a series of rosettes above or below wavy bands were found in the area of Room Gamma 10. Marinatos interpreted these rosettes, which are strongly reminiscent of the relief wall-painting from Room 9 in Xeste 3, as imitations of inlaid works.[136]

COMPLEX DELTA

Fragments of plaster with representations of osier have been recovered from Room Delta 17. Unfortunately most of this wall-painting has been lost, washed away by the torrent which ran through this part of the site before excavation began.

EARLIER FRAGMENTS

As mentioned in the introduction, older fragments of plaster bearing painted decoration have been observed in several instances. As a rule these come from the infill of earlier phases of the settlement and indicate that the art of wall-painting did not constitute an innovation during the town's final floruit. Certain pieces of especial importance, the earlier date of which is indisputable, are those found underneath the preparatory layer on which the wall-paintings of the final phase were executed.

A fragment 27.5 × 13 cm from area 3b of Xeste 3 was found stuck to the back of a piece of plaster, the main surface of which is painted in yellow ochre. The decoration of the underlying piece consists of a reticulation of fine red bands on a yellow ochre ground.

A fragment from roughly the same area of Xeste 3 (North Room 3) was found stuck to the back of a piece of plaster, the main surface of which is painted pink. The decoration of the underlying piece consists of a network of red wavy bands linked by arcs at their points of convergence. The inside of the arcs is painted in yellow ochre.

A plaster fragment from the infill of the light-well (area 9) in the House of the Ladies is decorated with groups of tiny parallel red lines. The lower section of the light-well had fallen into disuse during the final phase of the settlement and had been infilled with debris from an earlier destruction, in which this particular fragment was found.

147

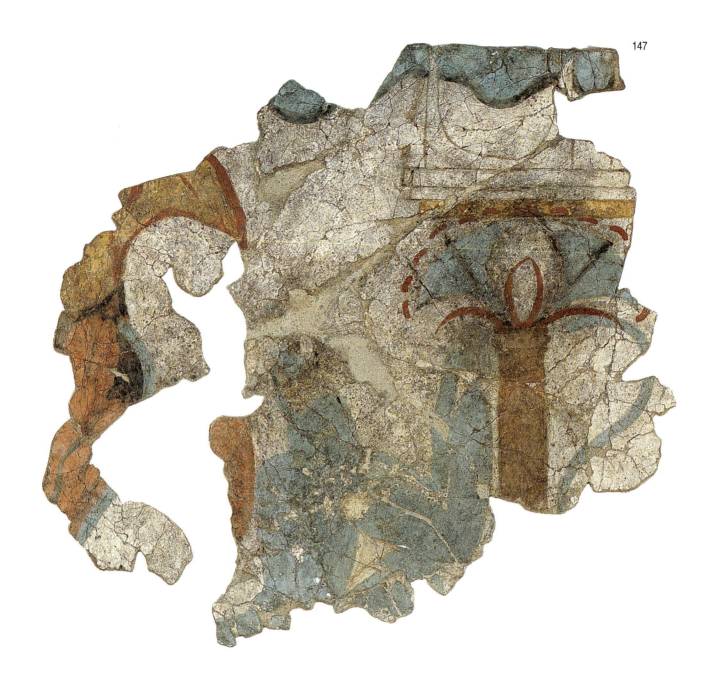

147. 'Altar' from the area of Sector Alpha.

148. 'The African' from the area of Sector Alpha.

149. House of the Ladies. Earlier wall-painting from the light-well.

150. Xeste 3. Earlier wall-painting.

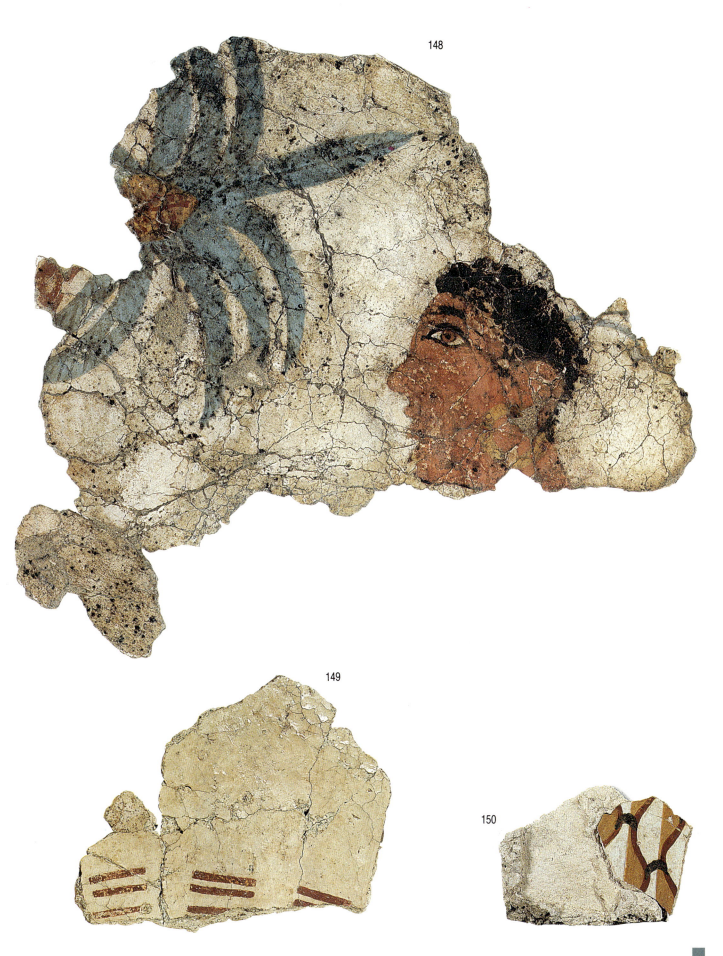

148

149

150

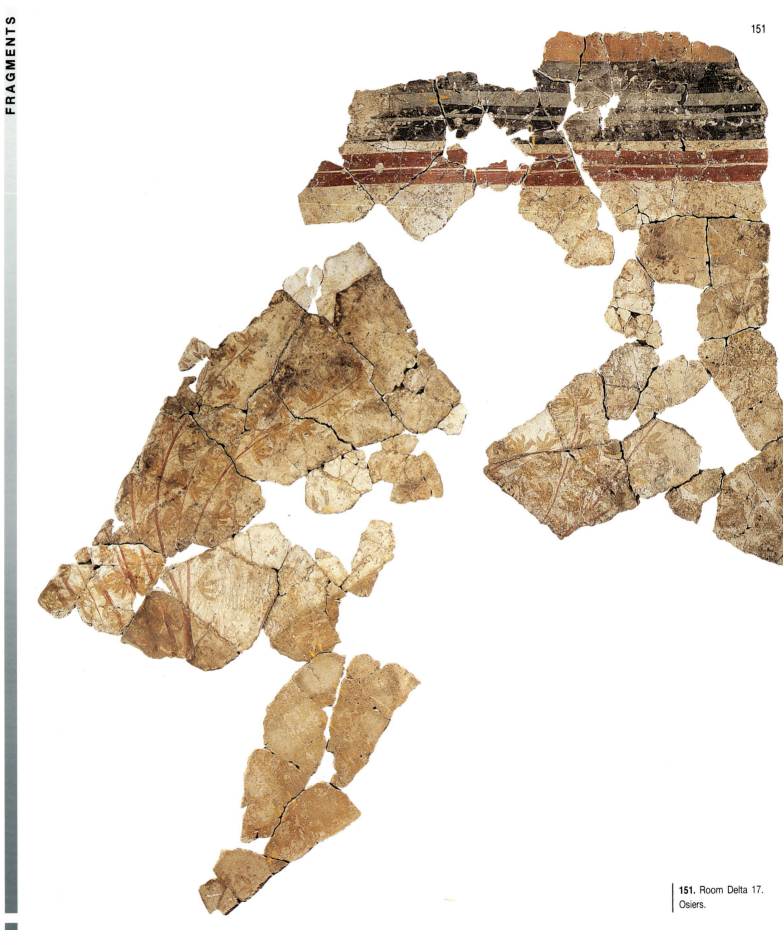

151. Room Delta 17.
Osiers.

ABBREVIATIONS

AAA — Athens Annals of Archaeology

Advances — M. Schiffer (ed.), *Advances in Archaeological Method and Theory*. Vol. 1. Cambridge 1978

AE — Ἀρχαιολογική Ἐφημερίς

Aegean Chronology — P. Åström, L.R. Palmer, L. Pomerance, *Studies in Aegean Chronology*. Gothenburg 1984

AJA — American Journal of Archaeology

BCH — Bulletin de Correspondance Hellénique

BICS — Bulletin of the Institute of Classical Studies

ΕΕΦΣΠΑ — Ἐπιστημονική Ἐπετηρίς τῆς Φιλοσοφικῆς Σχολῆς τοῦ Πανεπιστημίου Ἀθηνῶν

Ἡμερίδα — C. Doumas (ed.), Πρακτικά Ἡμερίδας Θήρας. Εἴκοσι χρόνια ἔρευνας: 1967-1987 (in press)

Iconographie minoenne — P. Darcque, J.-C. Poursat (eds.), *L'iconographie minoenne*. BCH, Suppl. XI, 1985

IJNAUE — International Journal of Nautical Archaeology and Underwater Exploration

JdI — Jahrbuch des Deutschen Archäologischen Instituts

JHS — Journal of Hellenic Studies

JMA — Journal of Mediterranean Archaeology

Minoan Society — O. Krzyszkowska and L. Nixon (eds.), *Minoan Society: Proceedings of the Cambridge Colloquium 1981*. Bristol 1983

Minoan Thalassocracy — R. Hägg and N. Marinatos (eds.), *The Minoan Thalassocracy. Myth and Reality*. Stockholm 1984

ΠΑΑ — Πρακτικά Ἀκαδημίας Ἀθηνῶν

ΠΑΕ — Πρακτικά τῆς ἐν Ἀθήναις Ἀρχαιολογικῆς Ἑταιρείας

Prehistoric Cyclades — J.A. MacGillivray and R.L.N. Barber (eds.), *The Prehistoric Cyclades*. Edinburgh 1984

TAW — *Thera and the Aegean World*. Proceedings of the Second International Scientific Congress, Santorini, Greece, August 1978. London 1978 (vol. 1) and 1980 (vol. 2)

TAW III — *Thera and the Aegean World*. Proceedings of the Third International Congress, Santorini, Greece, September 1989. London 1990

BIBLIOGRAPHY

ASIMENOS, K., 1978. Technological Observations on the Thera Wall-Paintings. *TAW*, 1, 571-578.

AXIOTI-SALI, T., 1992. Η Μικρογραφική Ζωφόρος της Θήρας και ο Όμηρος. *ΕΕΦΣΠΑ* ΚΘ´ (1986-1991), 459-469.

BAUMANN, H., 1984. *Η ελληνική χλωρίδα στο Μύθο, στην Τέχνη, στη Λογοτεχνία*. Athens.

BINTLIFF, J.L., 1984. Structuralism and Myth in Minoan Studies. *Antiquity* 58, 33-38.

BUCK, R.J., 1962. The Minoan Thalassocracy Re-examined. *Historia* 11, 129-137.

CAMERON, M., 1978. Theoretical Interrelations among Theran, Cretan and Mainland Frescoes. *TAW*, 1, 579-592.

CASSON, L., 1975. Bronze Age Ships. The Evidence of the Thera Paintings. *IJNAUE* 4.1, 3-10.

COULOMB, J., 1981. Les boxeurs minoens. *BCH* CV, 27-40.

DAVIS, H., 1983. The Iconography of the Ship Fresco from Thera. In W.G. Moon (ed.), *Ancient Greek Art and Iconography*. Madison, 3-14.

DAVIS, H., 1986. Youth and Age in the Thera Frescoes. *AJA* 90, 399-406.

DAVIS, H., 1990. The Cycladic Style of the Thera Frescoes. *TAW III*, 1, 214-228.

DOUMAS, C., 1977. Ἀνασκαφή Θήρας 1975. *ΠΑΕ*, 212-229.

DOUMAS, C., 1979. Ἀνασκαφή Θήρας 1976. *ΠΑΕ*, 309-329.

DOUMAS, C., 1980. Ἀνασκαφή Θήρας 1977. *ΠΑΕ*, 387-399.

DOUMAS, C., 1980a. Ἀνασκαφή Θήρας 1978. *ΠΑΕ*, 219-228.

DOUMAS, C., 1981. Ἀνασκαφή Θήρας 1979. *ΠΑΕ*, 259-267.

DOUMAS, C., 1982. Ἀνασκαφή Θήρας 1980. *ΠΑΕ*, 289-296.

DOUMAS, C., 1983. *Cycladic Art*. London.

DOUMAS, C., 1983a. *Thera: Pompeii of the Ancient Aegean*. London.

DOUMAS, C., 1983b. Ἀνασκαφή Θήρας 1981. *ΠΑΕ*, 321-328.

DOUMAS, C., 1984. Ἀνασκαφή Θήρας 1982. *ΠΑΕ*, 263-266.

DOUMAS, C., 1985. Conventions artistiques à Théra et dans la Méditerranée orientale à l'époque préhistorique. *Iconographie minoenne*, 29-40.

DOUMAS, C., 1986. Ἀνασκαφή Θήρας 1983. *ΠΑΕ*, 312-315.

DOUMAS, C., 1987. Ἡ Ξεστή 3 καί οἱ Κυανοκέφαλοι στήν τέχνη τῆς Θήρας. *Εἰλαπίνη*, 151-159.

DOUMAS, C., 1990. The Elements at Akrotiri. *TAW III*, 1, 24-30.

DOUMAS, C., 1990a. Ἀνασκαφή Θήρας 1985. *ΠΑΕ*, 168-176.

DOUMAS, C., 1990b. Ἀνασκαφή Θήρας 1986. *ΠΑΕ*, 206-211.

DOUMAS, C., 1991. Ἀνασκαφή Θήρας 1984. *ΠΑΕ*, 340-348.

DOUMAS, C., 1991a. Ἀνασκαφή Θήρας 1987. *ΠΑΕ*, 241-254.

DOUMAS, C., 1991b. Thera's Prehistoric Harbour. *The Illustrated London News*, Royal Issue, 76-78.

DOUMAS, C. (in press). Ἀνασκαφή Θήρας 1990. *ΠΑΕ*.

EFFENTERRE, H. van, 1986. *Les Egéens*. Paris.

FILIPPAKIS, S.E., 1978. Analysis of Pigments from Thera. *TAW*, 1, 599-604.

GABALLA, G.A., 1976. *Narrative in Egyptian Art*. Mainz.

GESELL, G.C., 1980. The 'Town Fresco' of Thera: A Reflection of Cretan Topography. *Πεπραγμένα Δ´ Διεθνοῦς Κρητολογικοῦ Συνεδρίου, 1976*, 197-204.

GIESECKE, H.-E., 1983. The Akrotiri Ship Fresco. *IJNAUE* 12.2, 123-143.

GILMER, T., 1975. Ships of Atlantis. *Sea-Frontiers*, November-December, 351-358.

GOTTMANN, J., 1984. Orbits: The Ancient Mediterranean Tradition of Urban Networks. *The Twelfth J.L. Myres Memorial Lecture*. London.

HAUSER, A., 1984. Κοινωνική Ίστορία τής Τέχνης, 1. Athens.

HIGGINS, R., 1981. *Minoan and Mycenaean Art*. London.

HILLER, S., 1990. The Miniature Frieze in the West House – Evidence for Minoan Poetry? *TAW III*, 1, 229-236.

HÖCKMANN, O., 1978. Theran Floral Style in Relation to that of Crete. *TAW*, 1, 605-616.

HODDER, I., 1986. *Reading the Past*. Cambridge.

HOLLINSHEAD, M.B., 1989. The Swallows and Artists of Room Delta 2 at Akrotiri, Thera. *AJA* 93, 339-354.

HOOD, S., 1978. *The Arts in Prehistoric Greece*. (Penguin).

HOOD, S., 1984. A Minoan Empire in the Aegean in the 16th and 15th Centuries B.C.? *Minoan Thalassocracy*, 33-37.

ILIAKIS, K., 1978. Morphological Analysis of the Akrotiri Wall-Paintings of Santorini. *TAW*, 1, 617-628.

IMMERWAHR, S.A., 1977. Mycenaeans in Thera, Greece and the Eastern Mediterranean in Ancient History and Prehistory. In. K.H. Kinzl (ed.), *Studies Presented to Fritz Schachermeyr on the Occasion of his Eightieth Birthday*. Berlin - New York, 173-191.

IMMERWAHR, S.A., 1983. The Peoples in the Frescoes. *Minoan Society*, 143-153.

IMMERWAHR, S.A., 1985. A Possible Influence of Egyptian Art in the Creation of Minoan Wall Painting. *Iconographie minoenne*, 41-50.

IMMERWAHR, S.A., 1990. *Aegean Painting in the Bronze Age*. London.

IMMERWAHR, S.A., 1990a. Swallows and Dolphins at Akrotiri: Some Thoughts on the Relationship of Vase-Painting to Wall-Painting. *TAW III*, 1, 237-245.

JACOBSEN, T.W., 1981. The Beginning of Village Life in Greece. *Hesperia* 50, 303-319.

LAFFINEUR, R., 1983. Early Mycenaean Art: Some Evidence from the West House in Thera. *BICS* 30, 111-122.

LAFFINEUR, R., 1990. Composition and Perspective in Theran Wall-Paintings. *TAW III*, 1, 246-251.

LINARDOS, Y. (in press). Ό χῶρος στίς θηραϊκές τοιχογραφίες. *Ήμερίδα*.

MANNING, S., 1988. The Bronze Age Eruption of Thera: Absolute Dating, Aegean Chronology and Mediterranean Cultural Interactions. *JMA* 1, 17-82.

MANNING, S., 1990. The Eruption of Thera: Date and Implications. *TAW III*, 1, 29-40.

MARINATOS, N., 1984. Minoan Threskeiocracy on Thera. *Minoan Thalassocracy*, 167-178.

MARINATOS, N., 1985. The Function and Interpretation of the Frescoes at Akrotiri. *Iconographie minoenne*, 219-230.

MARINATOS, N., 1990. Minoan-Cycladic Syncretism. *TAW III*, 1, 370-377.

MARINATOS, S., 1967. Kleidung. *Archaeologia Homerica* I A. Göttingen.

MARINATOS, S., 1968. *Excavations at Thera I*. Athens.

MARINATOS, S., 1969. *Excavations at Thera II*. Athens.

MARINATOS, S., 1970. *Excavations at Thera III*. Athens.

MARINATOS, S., 1971. *Excavations at Thera IV*. Athens.

MARINATOS, S., 1971a. Life and Art in Prehistoric Thera. Albert Reckit Archaeological Lecture. *Proceedings of the British Academy* 57.

MARINATOS, S., 1972. *Excavations at Thera V*. Athens.

MARINATOS, S., 1972a. Θησαυροί ἐκ Θήρας. Athens.

MARINATOS, S., 1973. Άνδρῶν ἡρώων θεῖος στόλος. *AAA* VI, 289-292.

MARINATOS, S., 1973a. Μία ἱστορική τοιχογραφία ἐκ Θήρας. *ΠΑΑ* 48, 231-237.

MARINATOS, S., 1974. *Excavations at Thera VI*. Athens.

MARINATOS, S., 1974a. The Libyan Fresco from Thera. *AAA* VII, 87-94.

MARINATOS, S., 1974b. Das Schiffsfresko von Akrotiri, Thera. *Archaeologia Homerica* I. Göttingen, 140-151.

MARINATOS, S., 1976. *Excavations at Thera VII*. Athens.

MARTHARI, M., 1984. The Destruction of the Town at Akrotiri, Thera, at the Beginning of the LC I: Definition and Chronology. *Prehistoric Cyclades*, 119-133.

MEKHITARIAN, A., 1978. *La peinture égyptienne*. Geneva.

MORGAN, L., 1983. Theme in the West House Paintings at Thera. *AE*, 85-105.

MORGAN, L., 1985. Idea, Idiom and Iconography. *Iconographie minoenne*, 5-19.

MORGAN, L., 1988. *The Miniature Wall-Paintings of Thera*. Cambridge.

MORGAN, L., 1990. Island Iconography: Thera, Kea, Milos. *TAW III*, 1, 252-266.

MORRIS, S.P., 1989. A Tale of two Cities. *AJA* 93, 511-535.

NEGBI, O., 1978. The 'Miniature Fresco' from Thera and the Emergence of Mycenaean Art. *TAW*, 1, 645-656.

NIEMEIER, W.-D., 1990. Mycenaean Elements in the Miniature Fresco from Thera? *TAW III*, 1, 267-284.

NOLL, W., BORN, L., HOLM, R., 1975. Keramiken und Wandmalereien der Ausgrabungen von Thera. *Naturwissenschaften* 62, 87-94.

PALMER, L.R., 1984. The Linear B Palace at Knossos. *Aegean Chronology*, 26-119.

PALYVOU, C., 1984. The Destruction of the Town at Akrotiri, Thera at the Beginning of LC I: Rebuilding Activities. *Prehistoric Cyclades*, 134-147.

PARROT, A., 1958. *Mission archéologique de Mari. Le Palais II, 2: Peintures murales*, Paris.

PLATON, N., 1971. *Zakros. The Discovery of a Lost Palace of Ancient Crete*. New York.

PLATON, N., 1981. *La civilisation égéenne*, II. Paris.

PRYTULAK, M.G., 1982. Weapons on the Thera Ships? *IJNAUE* 11.1, 3-6.

RENFREW, C., 1967. Cycladic Metallurgy and the Aegean Early Bronze Age. *AJA* 71, 1-20.

RENFREW, C., 1972. *The Emergence of Civilization*. London.

RUFFLE, J., 1977. *Heritage of the Pharaohs*. Oxford.

SAKELLARIOU, A., 1980. The West House Miniature Frescoes. *TAW*, 2, 147-153.

SCHACHERMEYR, F., 1978. Akrotiri – First Maritime Republic? *TAW*, 1, 423-428.

SCHÄFER, J., 1977. Zur Kunstgeschichtlichen Interpretation Altägäischer Wandmalerei. *JdI* 92, 1-23.

SCHÄFFER, H., 1974. *Principles of Egyptian Art*. Oxford.

SHAW, M.C., 1980. Painted 'Ikria' at Mycenae? *AJA* 84, 167-179.

SHAW, M.C., 1982. Ship Cabins of the Bronze Age Aegean. *IJNAUE* 11.1, 53-58.

SULLIVAN, A., 1978. Inference and Evidence in Archaeology: A Discussion of the Conceptual Problems. *Advances* 1, 183-211.

TELEVANTOU, C.A., 1982. Ή γυναικεία ἐνδυμασία στήν προϊστορική Θήρα. *AE*, 113-135.

TELEVANTOU, C.A., 1984. Κοσμήματα ἀπό τήν προϊστορική Θήρα. *AE*, 14-54.

TELEVANTOU, C.A., 1990. New Light on the West House Wall-Paintings. *TAW III*, 1, 309-326.

TZAVELLA-EVJEN, C., 1970. Τά πτερωτά ὄντα τῆς προϊστορικῆς ἐποχῆς τοῦ Αἰγαίου. Athens.

VANSCHOONWINKEL, J., 1983. Les fresques à figuration humaine de Théra: Analyse iconographique. *Revue des Archéologues et Historiens d'Art de Louvain* XVI, 9-50.

VANSCHOONWINKEL, J., 1990. Animal Representations in Theran and Other Aegean Arts. *TAW III*, 1, 327-347.

WACHSMANN, S., 1980. The Thera Waterborne Procession Reconsidered. *IJNAUE* 9.4, 287-295.

WARREN, P., 1976. Did Papyrus Grow in the Aegean? *AAA* IX, 89-95.

WARREN, P., 1979. The Miniature Fresco from the West House at Akrotiri, Thera, and its Aegean Setting. *JHS* XCIX, 115-129.

WIENER, M., 1990. The Isles of Crete? The Minoan Thalassocracy Revisited. *TAW III*, 1, 128-161.

WILLETS, R.F., 1962. *Cretan Cults and Festivals*. London.

NOTES

1. Morgan 1990, 263.
2. Hood 1978, 48; Immerwahr 1990, 35.
3. Immerwahr 1990, 35.
4. Jacobsen 1981, 306; Renfrew 1972, 442.
5. Negbi 1978, 650; Tzavella-Evjen 1970, 65-68, 92.
6. Hood 1978, 83; Platon 1981, 11.
7. Platon 1981, 11.
8. Asimenos 1978, 577; Hood 1978, 83.
9. Asimenos 1978, 574. For scientific analyses of plaster and pigments see also: Filippakis 1978; Immerwahr 1990, 15-17; Noll et al. 1975.
10. Hood 1978, 83-84.
11. Doumas 1983, 40; Renfrew 1967, 12.
12. Filippakis 1978, 601; Hood 1978, 84.
13. Iliakis 1978, 628.
14. Hood 1978, 84; Immerwahr, 1990, 15; Platon 1981, 13.
15. Immerwahr 1990, 53-54.
16. Morgan 1990, 262.
17. Iliakis 1978, 618; Immerwahr 1990, 11-13.
18. Iliakis 1978, 621.
19. Morgan 1990, 263.
20. Higgins 1981, 95.
21. Hood 1978, 234.
22. Platon 1981, 14.
23. Hauser 1984, 49.
24. Hauser 1984, 54.
25. Iliakis 1978, 626.
26. Renfrew in *TAW III*, 1, 251.
27. Cf. Gaballa 1976, 3.
28. Davis 1986, 399-406.
29. Doumas 1987, 156.
30. Davis 1986, 401; Doumas 1987.
31. Gaballa 1976, 5.
32. Schäffer 1974, 177.
33. Schäffer 1974, 186-187.
34. Schäffer 1974, 187.
35. Televantou 1990, 323.
36. E.g. Cameron 1978, 590; Giesecke 1983, 130; Höckmann 1978, 607; Hood 1978, 55; Immerwahr 1990, 4; Laffineur 1990, 247; Marinatos S. 1976, 34.
37. Hood 1978, 54.
38. Effenterre, van 1986, 103.
39. Cameron 1978, 586.
40. Effenterre, van 1986, 103.
41. Immerwahr 1983, 144, 149.
42. Buck 1962, 136; Hood 1978, 54; Hood 1984, 34; Immerwahr 1990, 4; Marinatos N. 1984; Marinatos N. 1990, 370-377; Niemeier 1990, 279; Wiener 1990, 153-155.
43. Davis 1990, 226; Effenterre, van 1986, 103; Höckmann 1978, 615; Hood 1978, 238; Morgan 1990, 258.
44. Cameron 1978, 586.
45. Morris 1989, 513.
46. Sullivan 1978, 191.
47. Bintliff 1984, 35.
48. Hodder 1986, 6.
49. Marinatos S. 1972, 43.
50. Marinatos N. 1984, 29.
51. Marinatos N. 1984, 35.
52. Marinatos S. 1971, 49; Marinatos N. 1984, 109-111.
53. Marinatos N. 1984, 116.
54. Marinatos N. 1984, 104.
55. Marinatos N. 1984, 94.
56. Immerwahr 1990, 46; Marinatos N. 1984, 104.
57. Schachermeyr 1978, 423-425.
58. Doumas 1990, 29-30.
59. Hauser 1984, 66.
60. Hauser 1984, 70-71.
61. Hauser 1984, 74-75.
62. Doumas 1983a, 43; Marinatos S. 1972, 9; Marthari 1984, 132.
63. Marinatos S. 1972, 45.
64. Room 3b: fine network pattern on yellow ochre background; Room 3a: interconnected wavy bands.
65. Room 9: Doumas (in press).
66. Doumas 1983a, 139.
67. Manning 1988, 47; Manning 1990, 30-37.
68. Televantou 1990, 311.
69. Parrot 1958, 10-11.
70. Parrot 1958, 67.
71. Immerwahr 1990, 34; Parrot 1958, 110.
72. Parrot 1958, 33-34; above note 64.
73. Parrot 1958, 109.
74. Hood 1978, 51; Immerwahr 1990, 41; Palmer 1984, 109.
75. Doumas 1991a, 244 ff.; Marinatos S. 1972, 11 ff., 38 ff.
76. Marinatos S. 1972, 13.
77. Marinatos S. 1972, 39.
78. Warren 1976, 91.
79. Baumann 1984, 174, pls. 358-359.
80. Marinatos S. 1972, 39.
81. Marinatos S. 1972, 39-40.
82. Marinatos S. 1967, A26-29.
83. Marinatos S. 1972, 13, 38; Marinatos N. 1984, 97, 104.
84. Cf. Hauser 1984, 64.
85. Marinatos S. 1974, 35-36.
86. Linardos (in press).
87. Marinatos 1972, 43.
88. Televantou 1990, 313-322.
89. Marinatos S. 1974, 40.
90. Televantou 1990, 322.
91. Doumas 1985, 29-30.
92. Morgan 1988, 24.
93. Marinatos S. 1974, 49; Morris 1989, 514.
94. Doumas 1991b, 78.
95. Hood 1978, 65; Marinatos S. 1974, 53-57.
96. Sakellariou 1980, 150-151.
97. Immerwahr 1977, 183.
98. Morgan 1983, 99.
99. Gesell 1980, 204.
100. Axioti-Sali 1992; Morris 1989.
101. Doumas 1991b, 78; Gottmann 1984, 5.
102. Televantou 1990, 310-312.
103. Immerwahr 1990, 47; Marinatos S. 1971, 52; Marinatos N. 1984, 94.
104. Marinatos S. 1971, 21-25.
105. Marinatos S. 1976, 14, pl. 15a.
106. Marinatos S. 1971, 49.
107. Marinatos S. 1971, 47.
108. Marinatos S. 1971, 46.
109. Marinatos S. 1972, 38.
110. Marinatos S. 1972, 37, pl. 91.
111. Marinatos S. 1976, 23.
112. Marinatos S. 1976, 23, 25.
113. Marinatos S. 1976, 27.
114. Marinatos S. 1976, 25.
115. Doumas 1985, 31.
116. Marinatos S. 1976, 25.
117. Hood 1978, 146, fig. 140; Platon 1971, 63-67; Doumas 1982, 295, fig. 4.
118. Schäffer 1974, 286.
119. Mekhitarian 1978, 128, 135.
120. Doumas 1987, 154-158.
121. Marinatos S. 1976, 27.
122. Marinatos S. 1976, 33.
123. Marinatos S. 1974, 17; Marinatos S. 1976, 36.
124. Marinatos S. 1976, 27.
125. Doumas 1977, 227-229; Marinatos S. 1976, 21.
126. Doumas 1980a, 223.
127. Doumas 1980, 390.
128. Marinatos S. 1972, 18, pls. 24b, 25.
129. Hood 1978, 236.
130. Hood 1978, 236; see also Ruffle 1977, 174, fig. 132.
131. Marinatos S. 1969, 54, col. pl. B2.
132. Marinatos S. 1969, 53-54, fig. 43.
133. Marinatos S. 1969, 54, col. pl. B3.
134. Marinatos S. 1972, 15.
135. Marinatos S. 1970, 38, 62-63, col. pl. B2.
136. Marinatos S. 1970, 63, pls. 59b, 60.

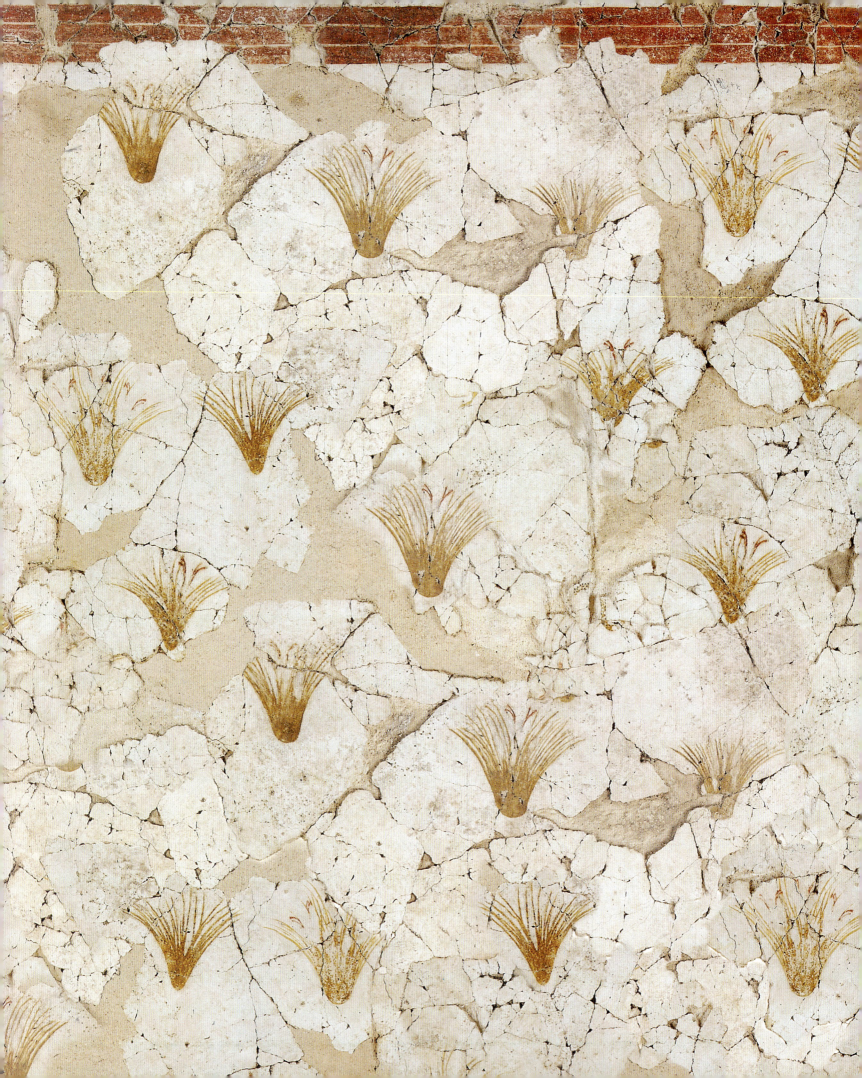